Thomas Gainsborough

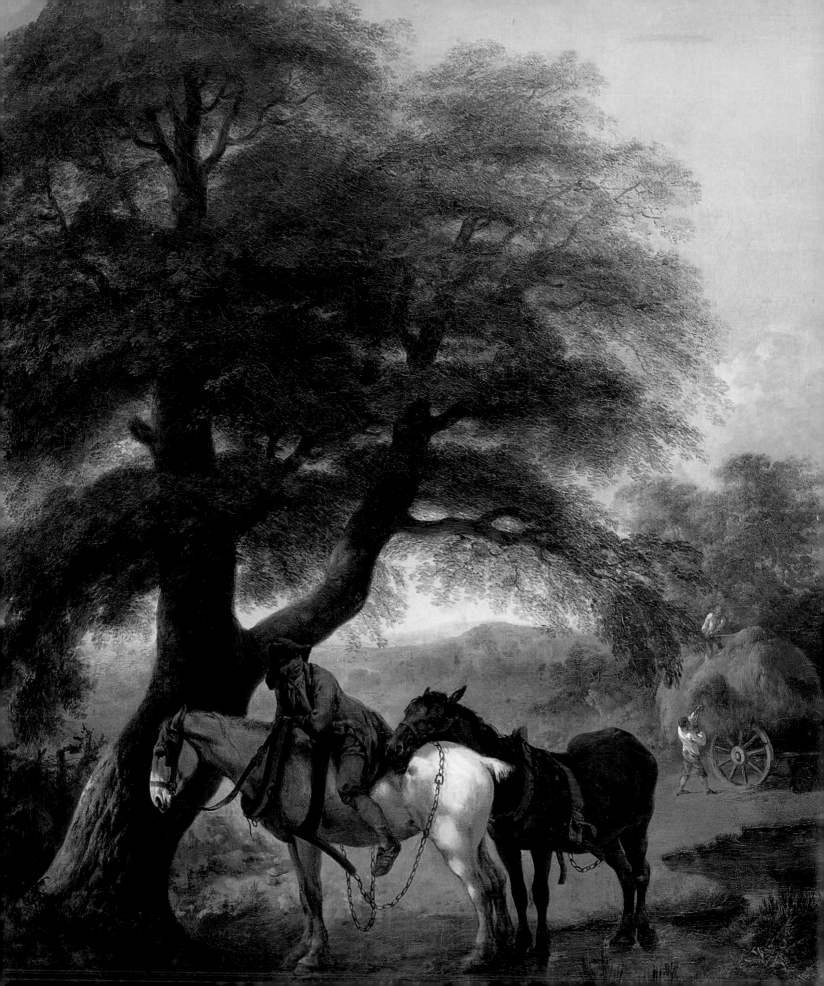

Hugh Belsey

Thomas Gainsborough

A Country Life

Prestel

Munich · Berlin · London · New York

Front jacket: Detail of Thomas Gainsborough, *Portrait of Mr and Mrs Andrews*, c. 1750.
 Oil on canvas, 69.8 x 119.4 cm. © National Gallery, London.
Back jacket: Thomas Gainsborough, *St Mary's Church, Hadleigh, Suffolk*, 1747–48.
 Oil on canvas, 91.4 x 190.5 cm. Private Collection, England.
Frontispiece: Detail of Thomas Gainsborough, *Landscape with Peasant and Horses*, 1755.
 By kind permission of the Marquess of Tavistock and the Trustees of the
 Bedford Estates.

Prestel-Verlag
Königinstr. 9
D-80539 Munich
Tel.: (89) 38-17-09-0
Fax.: (89) 38-17-09-35
www.prestel.de

4 Bloomsbury Place
London WC1A 2QA
Tel.: (020) 7323 5004
Fax.: (020) 7636 8004

175 Fifth Avenue, Suite 402
New York, NY 10010
Tel.: (212) 995 2720
Fax.: (212) 995 2733
www.prestel.com

Library of Congress Control Number: 2002109531

Prestel books are available worldwide. Please contact your nearest bookseller
or any of the above addresses for information concerning your local distributor.

Editorial direction: Philippa Hurd
Typography, design and production: Heinz Ross, Obergries (heinzross@t-online.de)
Cartography by Anneli Nau, Munich

Origination: Horlacher GmbH, Heilbronn
Printing: Jütte-Messedruck Leipzig GmbH
Binding: Kunst- und Verlagsbuchbinderei GmbH, Baalsdorf near Leipzig

Printed in Germany

ISBN: 3-7913-2784-4

Contents

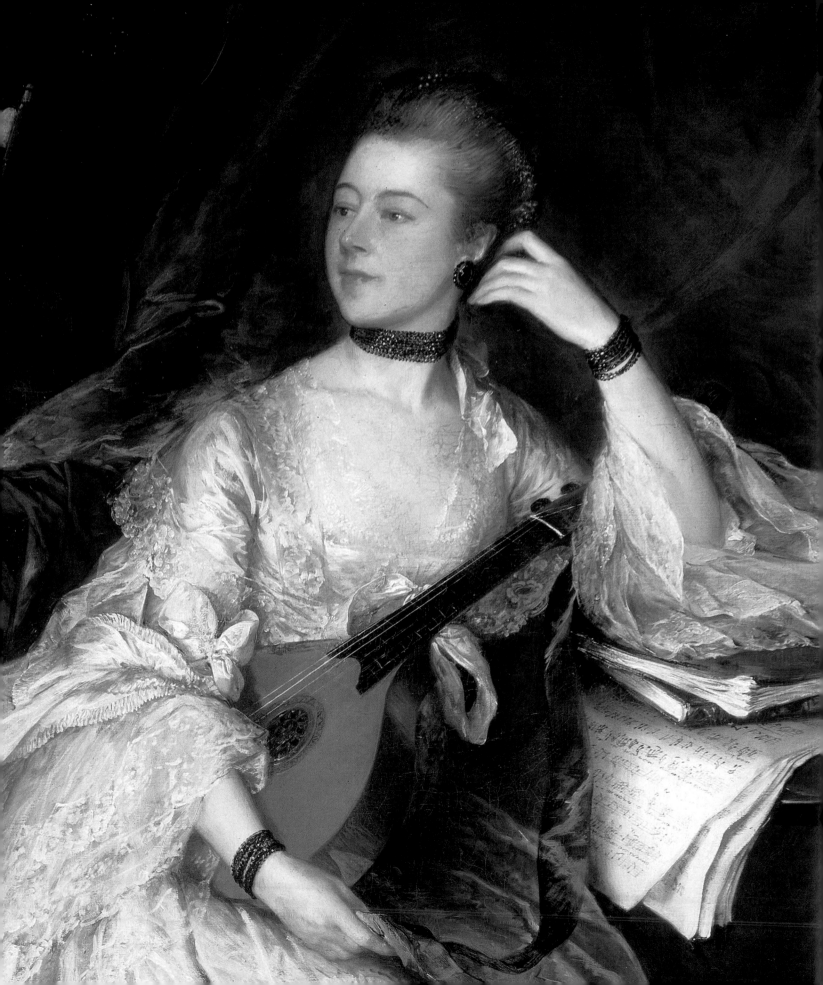

Introduction

Two of the most revealing observations on Thomas Gainsborough's character come from a mercurial actor and a fellow artist who, in other ways, was very far from understanding him. David Garrick is said to have described Gainsborough's cranium as 'so crammed with genius of every kind that it is in danger of bursting upon you, like a steam-engine overcharged'.[1] Sir Joshua Reynolds was fascinated by Gainsborough's highly developed sense of observation: 'He had a habit of continually remarking to those who happened to be about him, whatever peculiarity of countenance, whatever accidental combination of figures, or happy events of light and shadow, occurred in prospects, in the sky, in walking the streets, or in company. … He neglected nothing which could keep his faculties in exercise, and derived hints from every sort of combination'.[2] Given these extraordinary qualities, it is perhaps surprising that it took Gainsborough so long to find his own, very personal, means of expressing them. However, a shotgun wedding, the death of a daughter, and a wife with a sizeable income might frustrate anyone starting a career. Moreover, Gainsborough began to paint when artists were regarded as little more than artisans.

Gainsborough's identity as an artist has always been confused by the dual nature of his work. Before he moved to Bath permanently in 1759 he produced doll-like figures in fresh East Anglian landscapes. But, after experiencing the sophistication of city life, his work changed and he painted in a style which, by the late nineteenth and early twentieth centuries, was regarded as the acme of elegance. Recent tastes for Georgian understatement have judged Gainsborough's early conversation pieces as evocations of the true artist and his later work as an abberation. Furthermore, as the only important eighteenth-century artist who made as great a contribution to landscape painting as to portraiture, the understanding of his work as a totality is often flawed. Without studying the artist's earliest works, contacts and influences or understanding the character of the man, however, there can be little effective appreciation of his later work and the manner in which he painted.

The period under examination provides the reader with some of the most potent images of the eighteenth century, such as the *Portrait of Mr and Mrs Andrews*, *Cornard Wood* and the *Portrait of Ann Ford*. After many partial appreciations of the artist, recent research has done much to help us understand the artist's formative years. Gainsborough's early work can be seen as a period of experimentation, self-education and redirection. Ultimately his move to Bath was a very successful attempt to launch himself on the road to becoming an artist of national, rather than just local, significance.

Detail of
Thomas Gainsborough,
Portrait of Ann Ford, 1760.
(see fig. 62, p. 85)

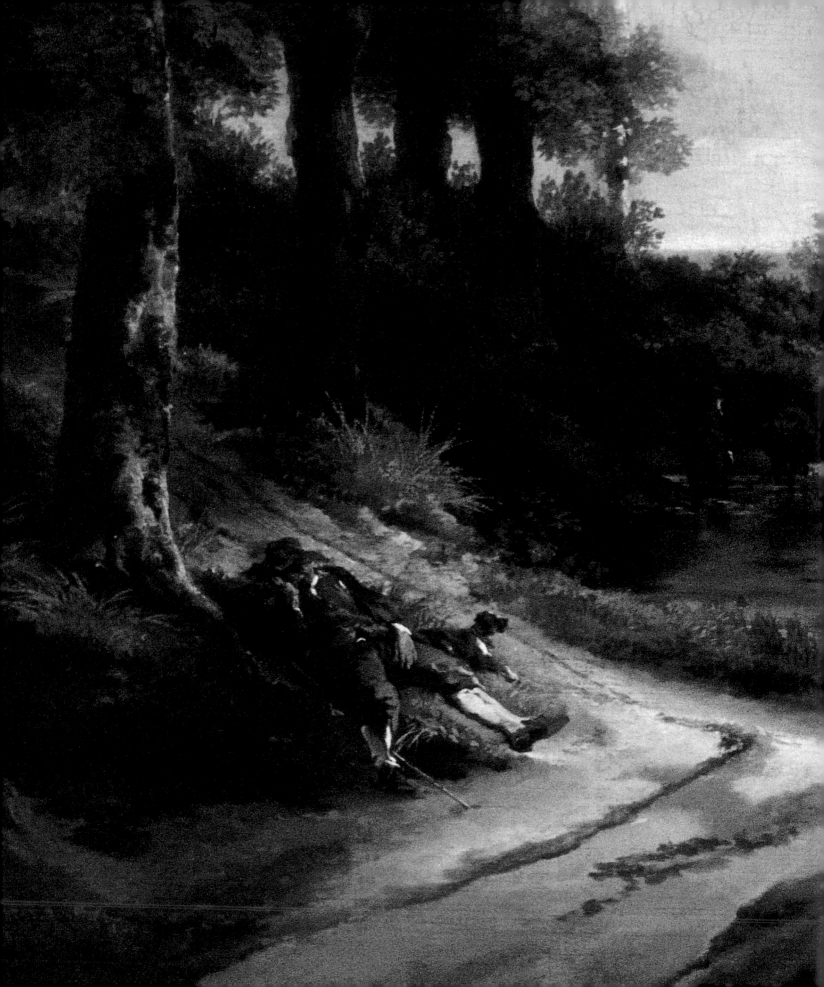

1 Learning in Suffolk and London

Detail of
Thomas Gainsborough,
Drinkstone Park, c. 1746.
(see fig. 11, p. 20)

Fig. 1
Thomas Gainsborough, *Self-portrait*, c. 1754.

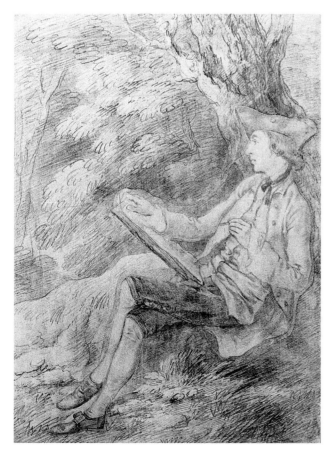

In 1722 Daniel Defoe described the market town of Sudbury in Suffolk: 'I know nothing for which this town is remarkable, except for being populous and very poor. ... The number of poor is almost ready to eat up the rich'.[3] Architecturally, at least, the town today shows little indication of any late seventeenth- and early eighteenth-century prosperity. However, the Stour Navigation Act of Parliament, passed in 1705, had provided an infrastructure which the town badly needed and which ensured that, eventually, it was able to benefit from the cheap exportation of raw materials, especially red and white bricks made from the local small clay deposits. Among the rich, who risked being eaten by the poor, was the artist's uncle, also called Thomas Gainsborough, who had done much to develop the weaving industry in the town. His son, also named Thomas and the artist's cousin, began trading successfully with Samuel Storke, a West Indian merchant based in New York, which further fused the success of the family with that of the town. Their pride is recorded in a series of six portraits of the family by the German *émigré* artist, John Theodore Heins, portraits which would have aroused the interest of their painter cousin, Thomas.

The elder Thomas's younger brother, John, was always in his shadow and, commercially at least, was much less successful. On 6 July 1704 John Gainsborough married Mary Burroughs, the daughter of an Anglican clergyman. Her brother, Henry, also went into the church and from 1723 to 1755 was the headmaster of Sudbury Grammar School. They had nine children, the youngest of whom was the artist. In 1722 John Gainsborough purchased a house on Sepulchre Street. He immediately made alterations to the building by raising the roof to enable him to further embellish it with a well-proportioned brick façade. Unfortunately this confidence proved foolhardy. Within ten years he was declared bankrupt and in 1735 his nephew, John, had purchased the house and presumably rented it back to the artist's family. John Gainsborough was appointed postmaster to the town, a sinecure which, after his death, was taken over by his wife.

John and Mary Gainsborough's youngest child, Thomas, was born in the spring of 1727. The whole family came from a dissenting background and often used All Saints', the most fundamental of the three medieval churches in the town. The elder Thomas's true allegiance, however, was to the newly built Independent

Meeting House in Friars Street, and it was perhaps for this reason that the artist was baptised there on 14 May. In his early days he would have been receptive to the still-life and flower painting that his mother reputedly made, though the attribution of a couple of door panels and a self-portrait by the young Gainsborough is difficult to sustain.[4] He was taught by his maternal uncle at the local grammar school, and there are stories of forged letters addressed to his teachers excusing him from school. Truancy gave him time to sketch in the countryside around Sudbury. As one of his obituarists remarked: 'Nature was his teacher and the woods of Suffolk his academy; here he would pass in solitude his moments in making a sketch of an antiquated tree, a marshy brook, a few cattle, a shepherd and his flock, or any other accidental objects that were present'.[5] It became a landscape which he grew to admire as his eye became attuned to its varied intimacies. In 1739 rich uncle Thomas died leaving the teenager a legacy 'that he may be brought up to some Light handy Craft trade likely to get a comfortable maintenance by; and that they do give him any summe not exceeding twenty pounds to bind him out to such trade'; and another £10 'if he shall prove sober and likely to make good use of it, the better to enable him to set out into the world'. Shortly after, no doubt with the intention of making good use of the legacy, the young man moved to London, lodging with an unidentified silversmith who was described as an intimate friend of the family.[6]

An association with silverwork would have provided a perfect opportunity to learn engraving, a employable skill which was an obvious application of the young lad's abilities as a draughtsman. Indeed in the 1730s, encouraged by the publication of novels by, among others, Samuel Richardson and Henry Fielding, books illustrated with engravings had become best-sellers. Two men who would

Fig. 2
Gainsborough's House, street façade.

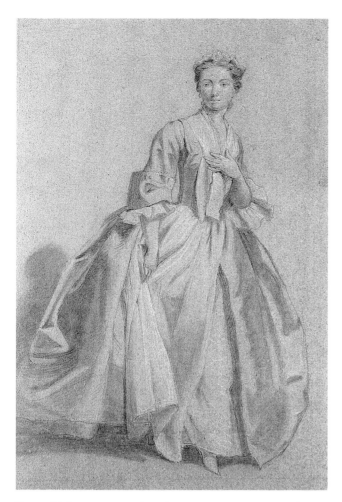

Fig. 3 Hubert-François Gravelot, *Study of a Woman*, c. 1744.

do much to fashion the young artist, Francis Hayman and the Frenchman Hubert-François Gravelot, had become leading engravers in the city. Nevertheless, at this early date, there is no evidence that Gainsborough learnt the technique. Tradition has it, however, that he assisted Gravelot in designing the rococo surrounds to historical portraits for some of Jacob Houbracken's popular engravings which were eventually published in two volumes in 1747 and 1752 as *The Heads of Illustrious Persons of Great Britain*. His friend and contemporary, the engraver Charles Grignion, remembers that he 'received his first instructions in the rudiments of art from Mr Gravelot'. And he no doubt subscribed to the St Martin's Lane Academy, an informal drawing club where, to quote Peter Camper: 'There are a man and a woman for models. The man poses three days, the woman two'. Campbell's *London Tradesman* of 1747 gives more details: 'The Subscribers, in their Turn, set the Figure; that is place the Man or Woman in such Attitude; in the Middle of the Room, as suits their Fancy: He who sets the Figure, chuses what seat he likes; and all the rest take their Place according as they stand in the best [of subscribers] and then proceed drawing, every Man according to his Prospect of the Figure'.[7]

In the winter of 1735 William Hogarth, the most influential artist working in the city, had decided to revitalise an Academy which had been started by his father-in-law, Sir James Thornhill in 1711. He joined forces with Gravelot who had come from France in 1732 to establish a drawing school, for in his own words, 'de English may be very clever in deir own opinions, but dey do not draw de draw'.[8] This environment not only provided the young Gainsborough with the formalities of drawing from life but also gave him the companionship and criticism he needed to develop his work. The Academy appears to have specialised in drawing full-length clothed models in black-and-white chalks on tinted paper, a technique which imitates the process of painting and one which Gainsborough was to use throughout his subsequent career. One account states that he had 'a short and unprofitable residence with Hayman' and this may well have been in connection with the large commission the older artist received for Vauxhall Gardens.[9]

Encouraged by a rival development at Ranelagh which opened in 1742, Jonathan Tyers, a entrepreneur of considerable ability, began to develop the pleasure gardens at Vauxhall, situated on the south side of the River Thames upstream from Lambeth Palace. Four years earlier Tyers had commissioned Louis-François Roubiliac to sculpt an informal statue of George Frideric Handel which was sited in the south walk of the gardens. A music pavilion was built and a series of supper-boxes lined the central quadrangle called the Grove. Fifty-three supper-boxes were to be decorated with eight-foot by five-foot canvases showing scenes from Shakespeare, children's games and other customs. The

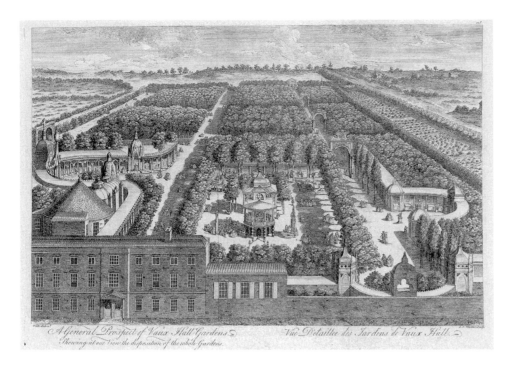

Fig. 4
Johann Sebastian Muller (1715–c. 1785)
after Samuel Wale (?1721–86),
A General View of Vauxhall Gardens, c. 1751.

brief was given to Francis Hayman with a tight timescale. There was much canvas to cover and little time to complete the commission. Hogarth was involved, as was Gravelot, and, through him, the young Gainsborough. In the engraving, the design of *Children Building Houses with Cards* (fig. 5) is given to Gravelot, but the painting of the boy and the standing figure beside him has a liveliness that is lacking in other paintings in the series.

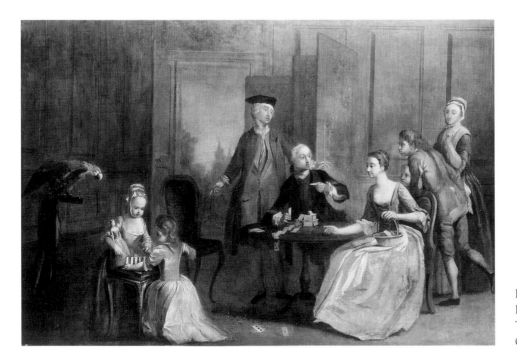

Fig. 5
Francis Hayman with
Thomas Gainsborough's assistance,
Children Building Houses with Cards, c. 1743.

What seems certain is that the young Gainsborough would have been involved in the project and have learnt many of the tricks of the trade that were being demonstrated in the makeshift studios that would have been set up to carry out the project. It also provided a better gallery of painting for the entertainment of the general public than anywhere else in the kingdom and the example fuelled Gainsborough's aspirations. In about 1743 he appears to have settled in Hatton Garden, lodging with John Jorden, who was probably training to become a Nonconformist Minister. It would have been in his house in Little Kirby Street that Gainsborough set up his first independent studio.

What is perhaps Gainsborough's earliest extant portrait, which can be dated to about 1744, has been mutilated, but the two surviving fragments show that the original canvas was painted on an ambitious scale and showed a brother and his older sister posing in a landscape (fig. 6). The girl is shown seated on a bank cradling freshly picked country flowers in her skirt, while her brother looks on

Fig. 6
Thomas Gainsborough,
Portrait of a Girl and Boy
(fragmentary), c. 1745.

nonchalantly holding a red poppy in his left hand. The painting was for many years attributed to William Hogarth and identified as children of the Mackinen family, sitters who had posed for the elder artist at about the same date. The mistake at least shows an affirmation of the quality of the painting and it is clear that the confidence in delineating the fine linen cuffs of the boy and the silk flowers in the hair of the girl can only have been painted by someone who has closely studied the subtleties of Hogarth's painting technique. The unity between figures and landscapes, created by an understanding of light, is something that is more difficult to attribute to the influence of other artists and can only be explained by Gainsborough's intimate understanding of the Suffolk landscape. There are, however, indications that at this early stage of his career his ambition outstripped his abilities and there are evident faults in the anatomical understanding of the boy's right ankle and of his hand, a defect that is even more evident in his *Portrait of Clayton Jones* of about 1744.

Very similar characteristics can be seen in the small portrait of a bull terrier, *'Bumper'* (fig. 7), which is full of nervous energy and described as a 'most remarkable sagacious curr' in a inscription on the back of the relined canvas — text which is presumably transcribed from the reverse of the original canvas. It is tempting to interpret the inscription as an assessment of the dog's character following some remarkable incident which was marked by the painting. The same inscription also provides a date: 'Pinxit Anno 1745'. Although much smaller in scale than the mutilated double portrait, the lack of a middle ground, the acutely observed characterisation of the dog and the intense delineation of lichen on the tree trunk parallel features already noted in the *Portrait of a Girl and Boy*. The tree on the right framing the composition and the screen of tree trunks against the light frequently recur in later works; and the careful balance of deep greens, buff to red-browns and white greys anticipates the balance of colour in the artist's compositions and, as in this canvas, eclipses the harmony of the forms. The dog portrait was made for for its owner, the Reverend Henry Hill, who sat for his own portrait a decade later.

By the time Gainsborough painted *Man in a Wood with a Dog* (fig. 8) just a year later we can see the extraordinary advance in the artist's abilities. The thrust of the sitter's left elbow towards the beholder is bold though not wholly successful and the location of the root of the dog's tail shows some anatomical misunderstanding. But the figure has presence. The full face demands a response from the beholder and a pentiment in the sitter's legs indicates a growing understanding of pictorial needs.

Although Gainsborough may have found his short stay in Hayman's house 'unprofitable', the two artists were intimately connected professionally. A letter from Francis Hayman to Grosvenor Bedford demonstrates how closely Hayman was working with the young Gainsborough. He had painted a portrait of Charles and Elizabeth Bedford for their father (fig. 9) and reported that he had 'an opportunity of getting the landscape done by Gainsborough whilst he is in Town'.[10] This telling phrase informs us that the young artist was often out of

Fig. 7
Thomas Gainsborough,
'Bumper', a Bull Terrier,
1745.

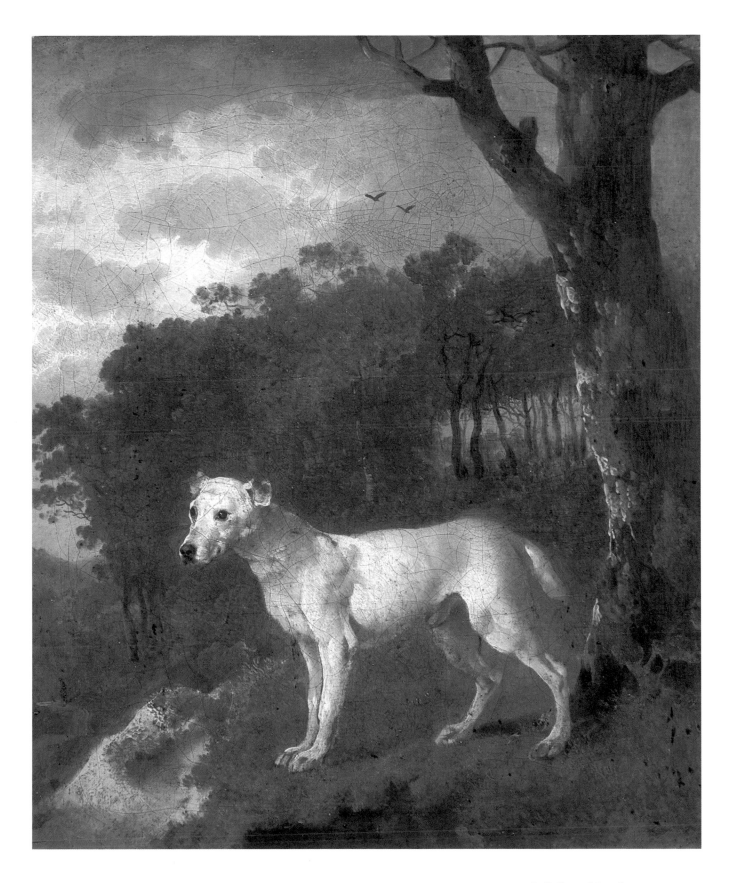

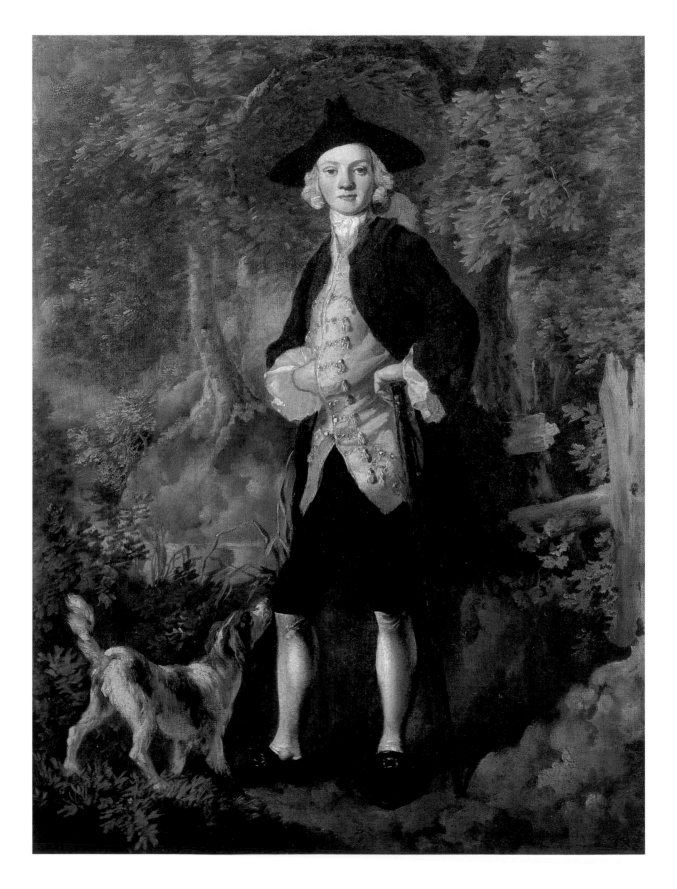

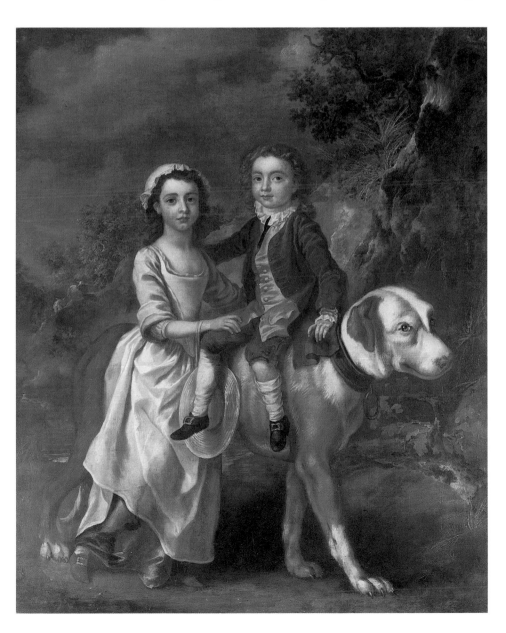

Fig. 8
Thomas Gainsborough,
Man in a Wood with a Dog, c. 1746.
Oil on canvas, 66 x 49.5 cm.

town, presumably visiting Sudbury to reacquaint himself with his native land-scape, and that he was regarded as something of a landscape specialist. Although it had been supposed for sometime, this document provides firm evidence that Gainsborough collaborated with other artists during the mid-1740s, and examination of the painting shows that the landscape has all the sensitivity of Gainsborough's handling. There is further evidence that the young artist worked with his contemporaries. In 1762 an auction lot included a landscape by Frans Wynantz, a little known painter, with 'the figures by Mr Gainsborough'.[11] Similarly, it has been convincingly suggested that, like the supper-box picture of *Children Building Houses with Cards*, Gainsborough worked with Gravelot to produce the canvas of a couple sitting on a bench in a park with a classical temple

Fig. 9
Francis Hayman and
Thomas Gainsborough,
*Portrait of Elizabeth
and Charles Bedford*,
c. 1746.

in the background (fig. 10). The narrative element, a vital component of book illustration, and the classical temple, sit very unhappily within Gainsborough's imagination and many commentators have remarked on the peculiarly French flavour to the painting. This can be fully explained if Gravelot produced the design which was then painted by Gainsborough. It is instructive to compare the handling of the foliage with the small landscape that remained with the family until it was given to the national collection.

In a reflective letter, written shortly before he died, Gainsborough remarked, 'I feel such fondness for my first imatations of little Dutch Land-skips'[12] and these must have provided him with amusement in the mid-1740s. The intensity of his observation and the contrasting colours of foliage inspired from different seasons give the small canvases a greater variety than nature. There have been several attempts to assume that they were painted in the fields, but the few that remain unfinished show that the landscapes were developed in a meticulous manner, building up the shapes and forms with individual pockets of colour. A number of them were placed in the hands of dealers, most notably Panton Betew, who would have sold them for very little. As we have seen in his dealings with Wynantz, Gainsborough's income was supplemented at this time by adding staffage to a number of contemporary landscapes and repairing Dutch paintings.

The mood of Gainsborough's early landscape in the period is an Anglicization of the work of Jan Wijnants and Nicholas Bercham. At this stage in his career direct quotations are unknown but Jan Wijnants inspires the gentle undulations in the landscape and the two artists share a love of tracks and travellers. Nicholas Bercham shares parallels in the handing of paint. The soft modelling in the sandy soil in the foreground of the *Man in a Wood with a Dog* (fig. 8) is very similar. The pastoral rhythm of Gainsborough's landscapes derived much from

Fig. 10
Thomas Gainsborough,
Conversation in a Park,
c. 1746.

Detail of Thomas Gainsborough,
Conversation in a Park, c. 1746.

Detail of Thomas Gainsborough, *Landscape with a Peasant on a Path*, c. 1746–47.

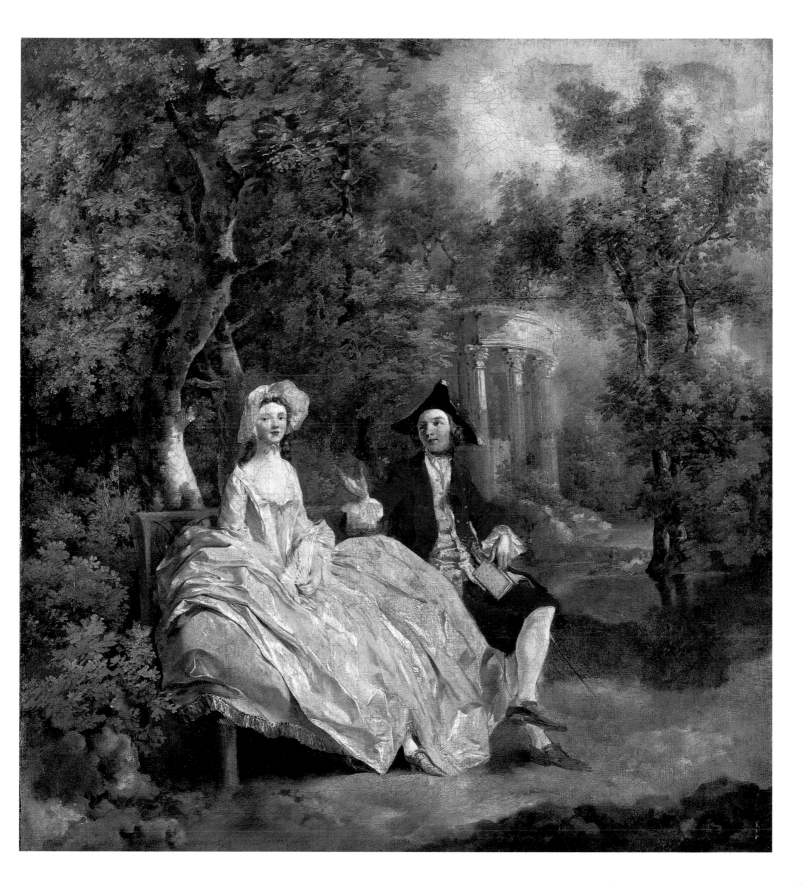

seventeenth-century Dutch painting and he would have had the opportunity to see many of them as they passed through London auction rooms.[13] From this period one firm piece of evidence exists. A black-and-white chalk drawing, resembling the technique so profitably learnt from the St Martin's Lane Academy (fig. 12), is a direct copy of a landscape by Jacob van Ruisdael which is known in several versions. It is assumed that Gainsborough would have seen one of the versions as it passed through London. It shares many of the features displayed in

Fig. 11
Thomas Gainsborough,
Drinkstone Park, c. 1746.

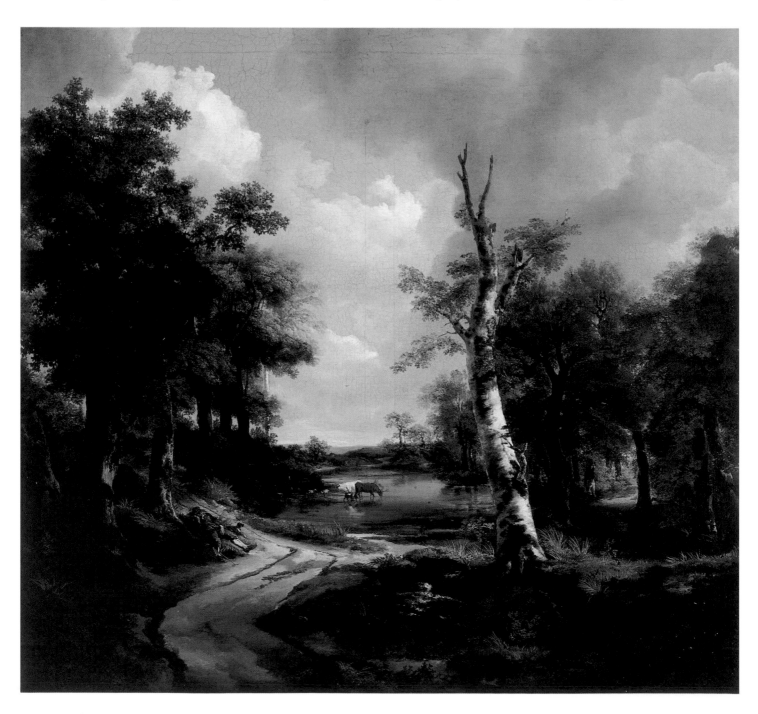

his own work and it is worthwhile making an extended comparison with this work and the large landscape painting known as *Drinkstone Park* (fig. 11).

The main feature in both drawing and painting is the trunk of an old silver birch tree with no more than a few wispy foliage branches in the centre. The white trunk, which contrasts with the deep green of the foliage of the other trees, divides the composition and frames the pool and cattle on the left and a woodland path on the right. A rutted track to the left brings the beholder into the composition; it rises up a bank and falls again to skirt the far side of the pool embracing the cattle in the centre of the composition. The billowing clouds echo the division of the landscape and extend the profile of the foliage into the sky. A traveller lies with his dog beside him near the track in an abandoned pose that suggests heavy sleep brought on by drinking too much ale. The Ruisdael has the same central silver birch trunk and the same proportional relationships between landscape, sky and water. Ruisdael's landscape embraces more human activity with a group of figures and cattle in the foreground and traveller and dog — not unlike the figure in *Landscape with a Peasant on a Path* (fig. 13) — describing the pathway through the wood on the left. Rather than being one of the 'small landscapes, which [Gainsborough] frequently sold to dealers at trifling

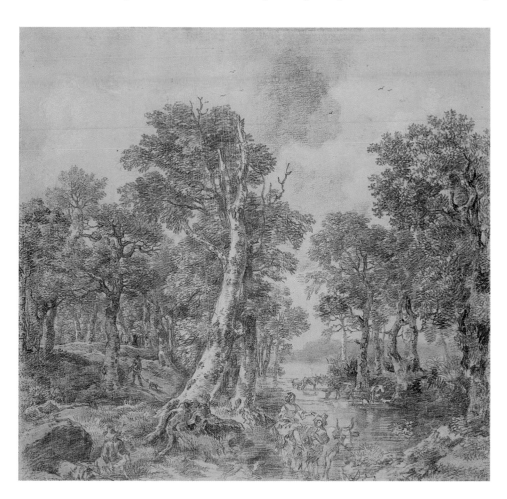

Fig. 12
Thomas Gainsborough,
Wooded Landscape with River,
Cattle and Figures
after Jacob van Ruisdael,
mid 1740s.

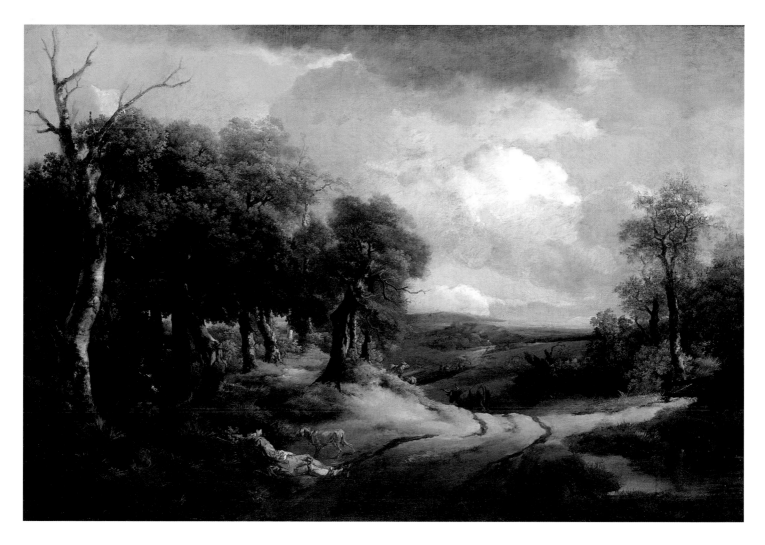

Fig. 14
Thomas Gainsborough,
Rest on the Way, 1747.

Fig. 13
Thomas Gainsborough,
Landscape with a Peasant on a Path,
c. 1746–47.

prices',[14] the landscape is amongst Gainsborough's largest and may well have been painted for a house close to Bury St Edmunds, Drinkstone Park, a name that has wrongly been associated with the subject of the painting.

An adaption of the landscape known as *Drinkstone Park*, is the landscape which Gainsborough unusually chose to sign and date (fig. 14). The painting of 1747 is also large and uses a dead silver birch tree to frame the composition and introduced the beholder to a similar rutted track which takes the eye towards the horizon. A more sober figure rests in the foreground with his dog beside him. The staffage introduces some local colour into the composition and focuses the beholder's attention before his eye is invited to travel along the track with the cow who disappears down the hill towards the horizon. Amongst the trees on the left is a second figure who, as the dog has noticed, stares directly at the beholder. Unfortunately the early history of the painting is unknown and so it can only be speculation that this figure was Gainsborough's patron, perhaps included as the butt of some private joke. The skyscape echoes the landscape beneath, with a dark cloud in the centre emphasising the path beneath.

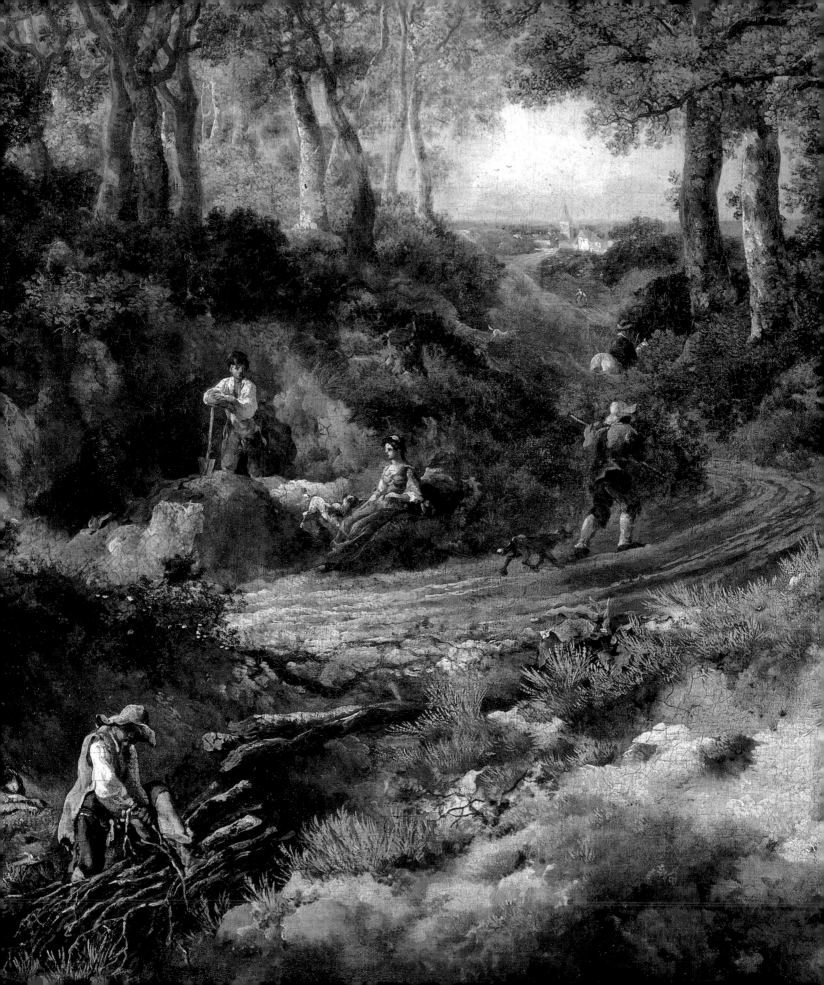

II Landscape into Art

On 15 July 1746 Gainsborough married Margaret Burr, the illegitimate daughter of Henry, Duke of Beaufort, in St George's Chapel, Curzon Street. Choosing Dr Keith's Mayfair Chapel, as it was sometimes called, was presumably directly related to the fact than Margaret was pregnant and the chapel made something of a speciality of performing clandestine marriages which required neither parental permission nor the calling of banns. The married couple moved into a house in Hatton Garden to the north of Gainsborough's lodgings with Mr Jorden, and soon afterwards a daughter, Mary, was born.

Nothing is known about the mother of Gainsborough's bride, though one observer thought she was the sister of a business associate of the artist's father and others that her family came from Scotland. It has, however, been established that the Duke, although he died in 1732, protected his daughter's welfare by providing an annuity of £200, which at the time was rather more than an average annual income. As well as providing the young couple with a level of financial security, the annuity also had a negative aspect. It questioned Gainsborough's ability to support his family and, despite the stigma of illegitimacy, it furnished Mrs Gainsborough with social aspirations which were to remains at odds with those of her husband's background. Nonetheless, Gainsborough had a true affection for his wife and she for him. During a severe illness in 1763 he describes how his 'Dear Good Wife has sat up every night til within a few and has given me all the Comfort that was in her power. I shall never be a quarter good enough for her if I mend a hundred degrees'.[15]

A portrait of the couple includes the only known likeness of their eldest daughter, Mary (fig. 15). She is shown as a toddler aged about eighteen months which helps to date the painting to the early months of 1748, shortly before the little girl's death. It shows the family posing in an Arcadian landscape (which may well be unfinished) seated on a conveniently placed bank beside a pool. The artist looks quizzically towards the beholder proffering a sheet of paper which, with the passage of time, is unfortunately blank. With his hand on his hip, his right elbow juts out and is a more successful *repoussoire* element than that painted in the earlier *Man in a Wood with a Dog* (fig. 8). Quite detached and seated to his right is his wife wearing a blue saque with large panniers and a gauze apron which emphasises the awkward serpentine line of her pose. Between them the ruddy-cheeked little girl leans against her mother as she fingers a posy of flowers. A dog on the bottom left-hand corner turns and drinks from the pool. Unlike dogs in other double portraits, this hound turns its back on the couple, and fails to fulfil its role as a symbol of loyalty and fidelity. As a

Detail of
Thomas Gainsborough,
Cornard Wood, 1748.
(see fig. 19, p. 30)

25

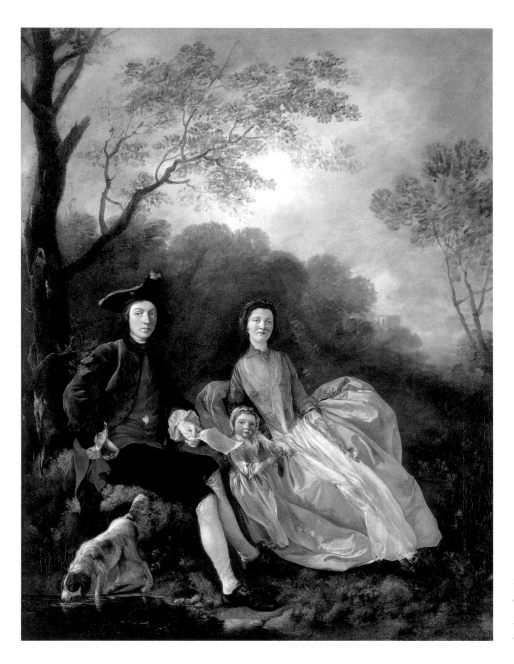

Fig. 15
Thomas Gainsborough,
Self-portrait with Wife and Daughter,
c. 1748.

private image, this may suggest friction between the couple, and a desire on behalf of the artist to revert to sowing a few more wild oats.

Commissions must have been scarce at this date and among the most important is the triple portrait of Peter Darnell Muilman with his future brother-in-law, the son of the very successful agent of North Carolina, Charles Crokatt, posing either side of their flute-playing tutor, William Keable (fig. 16). As a commission from very rich clients, Gainsborough approached the portrait with great sensitivity. He would have known Keable as a fellow student at the St Martin's Lane Academy and there are indications that this shadowy artist, also from Suffolk, who was thirteen years older than Gainsborough and better

Fig. 16
Thomas Gainsborough,
*Peter Darnell Muilman,
Charles Crokatt
and William Keable
in a Landscape*,
c. 1748.

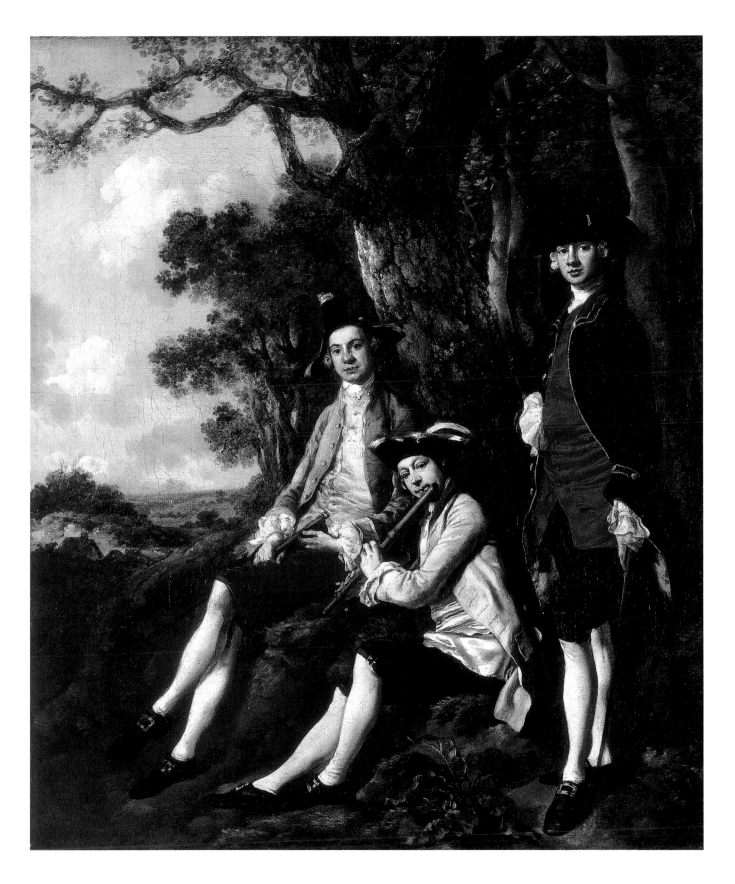

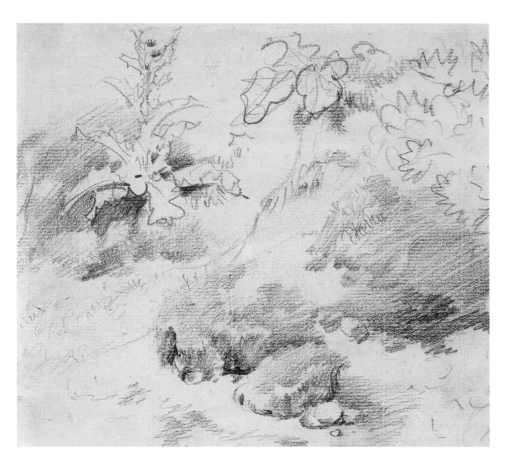

Fig. 17
Thomas Gainsborough,
Study for a Foreground,
a Bank with Weeds and Thistles,
c. 1750.

connected, had as close an association with him as did Hayman. The portrait, which must date from about 1748, shows the three figures posing before a dense wood with a surprisingly humble cottage and a distant view to the left. The figures are very different in handling. Muilman, probably the figure on the right, is posed like an illustration from a manual by a dancing master with his right hand tucked into his waistcoat and his left nervously grasping the top of a cane. He stands erect, the confidence of the pose and the interest in the profile — further emphasised by the gold edging of his coat — demonstrates the effect of Gravelot's teaching. On the other hand Crokatt, shown on the left, must have been fashioned from an over-tall lay figure, whereas Keable in the centre takes up a complex, though comfortable, pose which was probably studied from life. Keable can be identified positively by comparing the sitter with a self-portrait in the Mellon collection at Yale. The purple cast to his face and the definition of his features have encouraged the suggestion that the head is a self-portrait and his collaboration is suggested by a nineteenth-century label fixed to the back of the frame. Gainsborough has found an improbable bank on which to conveniently pose his figures. He must have used an earlier study for the veristically recorded oak trunk behind the sitter's head and for the handy clump of burdock leaves which fill the gap between the figures' feet. Both these features recall the extant pencil studies of nature which Gainsborough must have called

on to provide details for his more complex compositions (fig. 17). Sadly only a few of these drawings survive; there must have been many more. Returning to the artifice of the conversation piece, the three branches of foliage silhouetted against the sky are very obviously extended by the cloudscape. Perhaps these elements became more gauche when the artist lacked an obvious precedent in Dutch painting.

It is worth taking stock and comparing the Muilman conversation piece with a canvas by Francis Hayman of roughly the same date. Hayman painted a triple portrait of the proprietor of Vauxhall Gardens, Jonathan Tyers, with his daughter Elizabeth and her husband John Wood in about 1750 (fig. 18). The figure of the younger man provides an interesting parallel to the figure of Muilman both of whom look out of the canvas and attempt to engage the beholder in the world of the picture space. The cross glances in Hayman's picture are

Fig. 18
Francis Hayman (1708–76),
Jonathan Tyers with his daughter and son-in-law, Elizabeth and John Wood,
c. 1750.

Following pages:

Fig. 19
Thomas Gainsborough,
Cornard Wood, 1748.

Detail of Thomas Gainsborough,
Landscape with a Peasant on a Path,
c. 1746–47 (see fig. 13, p. 22).

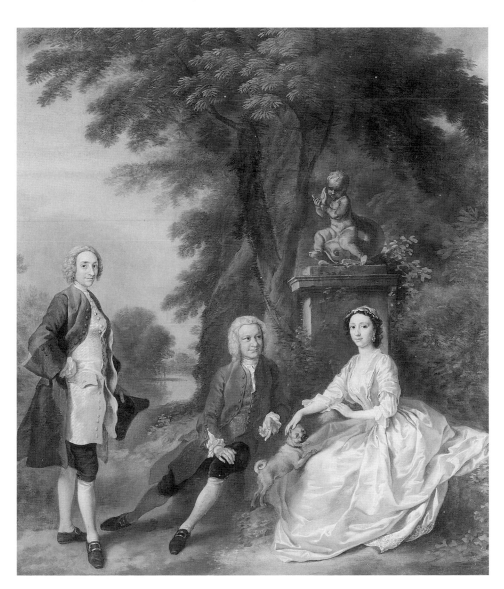

quite foreign to Gainsborough's concept and the landscape amply demonstrates, as we have already seen, why Hayman might wish to employ a landscape specialist to supplement his group portraits. In comparison with Gainsborough the figures sit in artificial park land complete with statuary, and the colours are subdued so as not to conflict with the brighter hues of the figures.

One of Gainsborough's great achievements in the early part of his career is the large landscape *Cornard Wood* which Gainsborough recalled late in life (fig. 19). He wrote in a letter to the Reverend Sir Henry Bate-Dudley: 'It may be worth remark, that though there is very little idea of composition in the picture, the touch and closeness to nature in the study of the parts and minutiae, are equal to any of my later productions. In this explanation, I wish not to seem vain or ridiculous, but do not look on the Landskip as one of my riper performances'. He continues: 'It is full forty years since it [the canvas] was first delivered by me

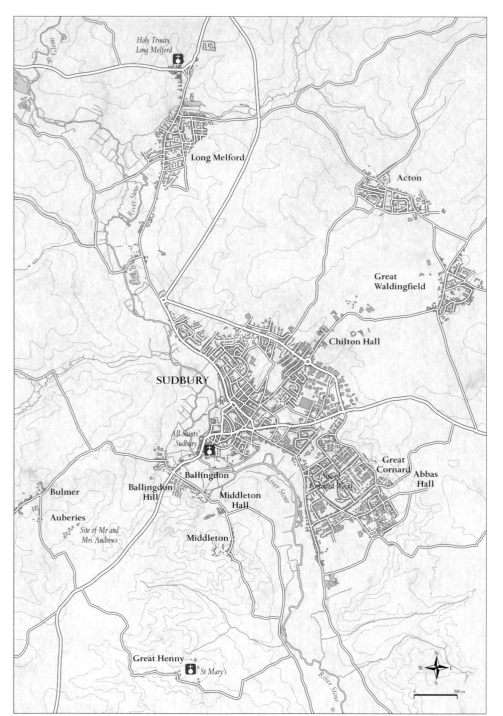

Fig. 20
Map of Sudbury and Long Melford area,
showing sites of *Cornard Wood*
and *Mr and Mrs Andrews*.

to go in search of those who had taste enough to admire it!'[16] So, one can deduce that it was never a commissioned painting but that it was painted for the artist's own satisfaction.

There are clear compositional similarities between Cornard Wood, the so-called *Drinkstone Park* (fig. 11) and the drawing copied from Ruisdael (fig. 12). In *Cornard Wood* the prominent central tree has become an oak in full leaf and the clump of trees on the left recall the arrangement in the small landscape which remained in the family collection until the nineteenth century (fig. 13). In this particular painting the topographical has been established: the canvas appears to show an amalgam of views from Abbas Hall, an ancient half-timbered house about two miles south-east of Sudbury. One of the views from the garden of the hall looks west across the Stour valley over the Essex border towards St Mary's, Great Henny, which is shown, in the canvas, breaking the horizon between the trees, and the other describes the undulating track leading to the Hall, the pond to the right and the rising ground to the left. The detail of the location can be seen on the map (fig. 20). What is also remarkable is the activity included in the landscape.

In the foreground a peasant completes his task of gathering wood for heating or cooking by tying up his bundle. This has taken some time as his dog has fallen asleep beside him. To the right are a pair of donkeys grazing beneath the central oak tree. In the centre another peasant rests from digging marl or (perhaps for the weaving industry) fuller's earth to speak to a woman who may own a cow which is grazing nearby. In the centre a dog follows a traveller and, further along the track, directly beneath the spire of Great Henny church, another rather grander traveller, dressed in the sober colours of a parson, rides a grey nag. The majority of the trees are oaks with the occasional silver birch to provide variety, and in the foreground Gainsborough gives himself the opportunity to include many studies of reeds, burdocks and grasses.

So what purpose do these figures serve? At one level they have a pictorial role. As Gainsborough himself said when advising an amateur landscapist: 'A regular Composition in the Landskip way should [be filled with] figures [which] fill a place (I won't say stop a Gap) or to create a little business for the Eye to be drawn from the Trees in order to return to them with more glee'.[17] However, the range of activity in *Cornard Wood* suggests an additional purpose for the figures. The first Acts of Enclosure in West Suffolk had been passed by Parliament as early as 1727, Oliver Goldsmith's poem *The Deserted Village*, published in 1770, synthesised the sentiments which were current at the time, and all that may be illustrated in this painting.[18] God the provider is represented by the overseeing church — a motif that frequently appears in the artist's landscapes — and, on this occasion, a figure of authority, perhaps a parson, is included for good measure. The prominent oaks, the symbol of England's power, and the artist's delight in the fecundity of nature are all too evident. This common ground is being used by the peasantry to supply pasture for cows and donkeys, wood for cooking and heating, and marl or fuller's earth for fertiliser or cloth preparation.

III Re-viewing the Landscape

Detail of
Thomas Gainsborough,
Portrait of Mr and Mrs Andrews, c. 1750.
(see fig. 28, pp. 42/43)

Fig. 21
Joseph Wood (d. 1763) after Joshua Kirby
(1716–74), *Lavenham Church from the South*,
1748.

Fig. 22
William Hogarth, *The Idle 'Prentice at Play
in the Church Yard during Divine Service*,
plate 3 from *Industry and Idleness*, 1747.

Unlike his competitor Sir Joshua Reynolds, Gainsborough was a religious man who refused to work on a Sunday though the tenor of his belief was held in check by his sister, Mrs Gibbons, a strict dissenter who was the frequent target of his good-hearted jibes. His next commission, a view of *St Mary's Church, Hadleigh, Suffolk* (fig. 23), includes a similarly light-hearted approach to religious matters. The canvas was commissioned by Dr Thomas Tanner, the Dean of Hadleigh, for an overmantel in the library which had been fitted out over the arch of the Deanery Tower about ten years before. In the painting the topographical detailing of the church and tower are quite unlike anything Gainsborough ever painted and an inscription on the back of an old stretcher associates the canvas with the name of Joshua Kirby, another pupil at St Martin's Lane Academy, who became one of Gainsborough's closest friends. At the time the canvas was being painted Kirby was producing designs for twelve engraved views of historic sites throughout Suffolk by Joseph Wood. One of them, the view of St Peter and St Paul, Lavenham (fig. 21), shows care in recording every architectural feature of the building and it seems likely Gainsborough worked with sketches of St Mary's, Hadleigh, provided by Kirby in the same way that he used drawings by Gravelot for the *Conversation in a Park* (fig. 10). He also included a number of details of his own invention.

The group of boys playing on a table tomb in the centre refers to the third plate from Hogarth's *Industry and Idleness* which had been published in October 1747 (fig. 22). This particular plate is entitled *The Idle 'Prentice at Play in the*

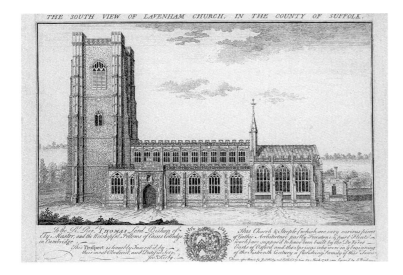

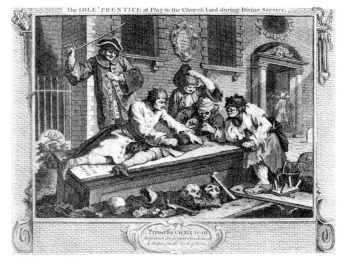

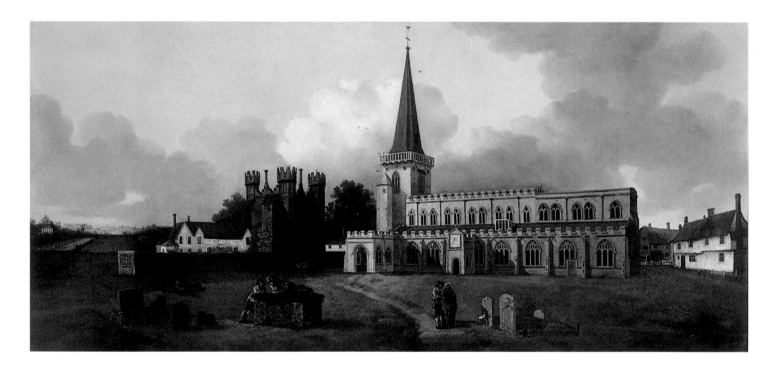

Church Yard during Divine Service and may well indicate that Dr Tanner was about his business inside the church at the time recorded by the painting. The other comment, the dog raising its leg against the tombstone on the right, a motif often found in Dutch paintings, does not recur in Gainsborough's work and must have been intended as a comment on, or a criticism of, Dr Tanner.

Following the artistic impetus generated by both the St Martin's Lane Academy and the decorations for Vauxhall Gardens a third venture had significant impact on the aesthetic world of London in the 1740s. Captain Thomas Coram had gained the Royal Charter for a Foundling Hospital in 1739 and, awaiting the funding and construction of a building which was to be designed by Theodore Jacobson, the fledgling hospital occupied two houses in Hatton Garden just to the south of Gainsborough's house. In 1745 the Hospital moved to their new purpose-built premises, and the artistic community, headed by William Hogarth, who had already presented the full-length portrait of Coram to the new institution in 1740, set out to decorate the Court Room (fig. 24). This was not entirely altruistic as the Hospital attracted many visitors and thus provided a means for the London public to see a group of paintings by contemporary artists. Hogarth, Hayman, Joseph Highmore and the Reverend James Wills each gave a large canvas illustrating a biblical story which featured the care of children. Between them were roundels of London hospitals, painted by less-established artists. These commissions

Fig. 24
Court Room of the Foundling Hospital.

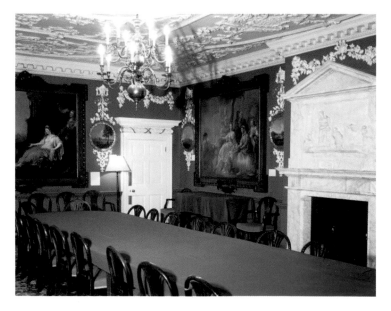

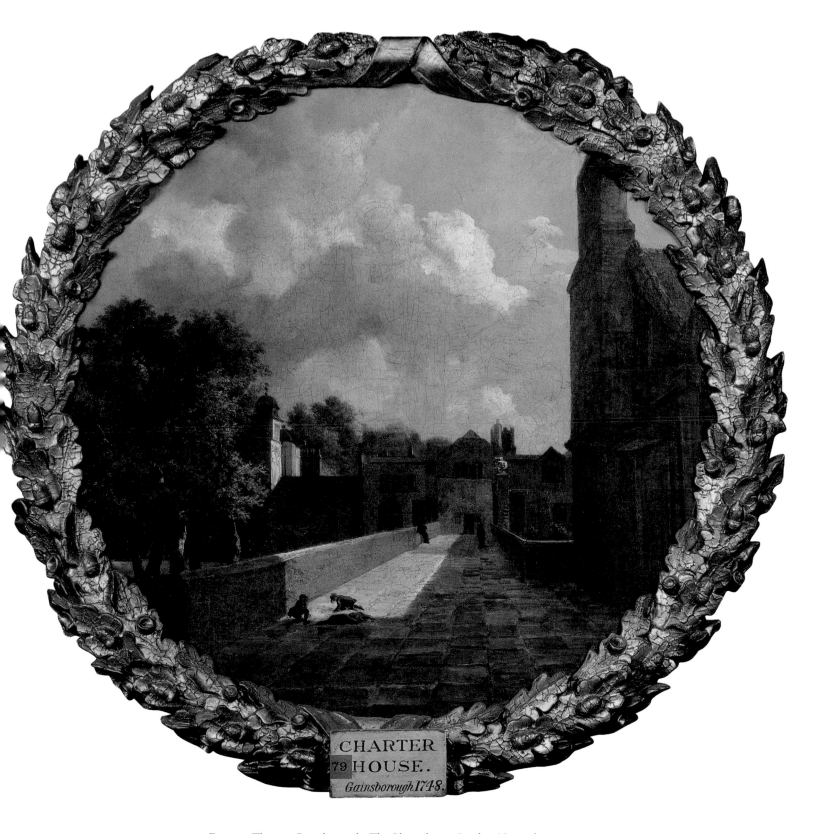

Fig. 25 Thomas Gainsborough, *The Charterhouse, London*, November 1748.

were made in order to raise the profile of native landscape painters who were sensitive to the appearance of a famous competitor from Venice; Canaletto had arrived in London in 1746 and begun to paint views up and down the Thames. Samuel Wale, Edward Haytley, Richard Wilson and Gainsborough were all asked to contribute roundels which were set in decorative plaster frames. Like Gainsborough, both Wale and Wilson had attended the St Martin's Lane Academy. Unlike the others in the group, Gainsborough painted only one roundel, *The Charterhouse, London*, a canvas he presented in November 1748 after the other seven were in place (fig. 25).

The view that Gainsborough chose to paint of the Charterhouse was not the most obvious. The composition is anchored by a monolithic chimney-stack on the right-hand side and a causeway which funnels the eye along a sharp perspective towards a doorway at the far end. The strong architectural effect is

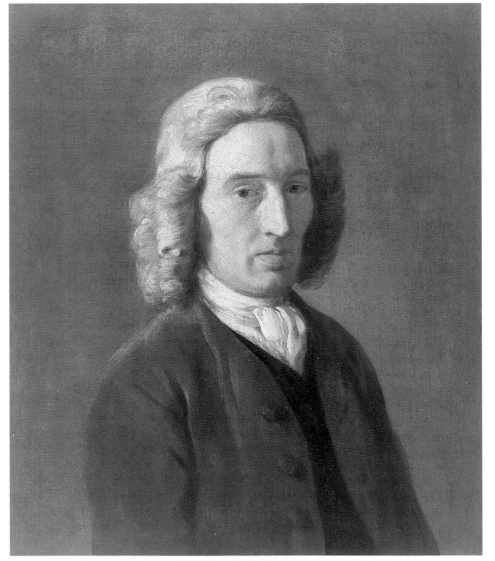

Detail of Thomas Gainsborough, *Portrait of a Girl and Boy* (fragmentary), c. 1745. (see fig. 6, p. 13)

Fig. 26
Thomas Gainsborough,
Portrait of John Gainsborough,
before November 1748.

enlivened by a momentary shaft of sunlight which strikes the urns on the top of an archway on the right, cuts the causeway in two and illuminates a bell turret on the left. The eye is momentarily arrested by boys playing marbles in the foreground and other figures who form punctuation marks along the causeway. To the left is an agitated Ruisdaelesque copse, and above, a lively cloudscape forms a distinct contrast to the fixed rectilinear shapes of the architecture. It was an important commission which Gainsborough fulfilled with distinction. According to George Virtue, who 'tho't [it] the best and [painted in a] masterly manner', he succeeded. It is interesting to note that while all the other roundels are painted on beige or grey grounds, Gainsborough, for the first time, used a red ground which gives his painting greater depth and, more importantly, provides a distinct contrast with the other canvases in the group.[19]

Gainsborough's young daughter, Mary, who had been shown leaning against her mother in the family group portrait, was buried in St Andrew's Church, Holborn on 1 March 1748. At about the same time Gainsborough painted a wistful portrait of his father (fig. 26). The canvas is an uncomplicated head-and-shoulders portrait cut off, as so often with Gainsborough, somewhat awkwardly above the stomach. He is shown three-quarter face wearing a deep blue coat, a white stock and a sumptuously painted wig. The features betray a diffident, gaunt face with a long, straight nose and full mouth, a face that was described as having 'humour and indecision … stamped on his features'.[20] It is worth comparing the treatment of the hair with that of the boy in the early double portrait (fig. 6). The painting has become freer in handling and more directly observed. Details such as the shadow on the sitter's right cheek and the fringe on the stock give the portrait the same intensity of observation that has already been noted in the landscapes. John Gainsborough died on 29 October 1748. Shortly afterwards the artist and his family rented a house in Friars Street, opposite the Independent Meeting House where he was baptised, and which had recently been inherited by his cousin, Mary.

The motives for the Gainsboroughs move back to East Anglia are unknown. Perhaps the death of their daughter encouraged them to abandon the city and raise a family in the country, a move which Thomas's father may have discouraged given that Thomas was married to a wife of questionable parentage. Moving back to Sudbury was clearly a happy event, however. His wife gave birth to another daughter, Mary, who was baptised in All Saints', Sudbury on 3 February 1750, and a third daughter, Margaret, was born eighteen months later and baptised in St Gregory's, Sudbury on 22 August 1751.

Gainsborough's painting also entered a more mature phase. *The Fallen Tree* is a large landscape which shows the usual conceits of a framing tree on the left, a smaller denser block of woodland on the right with a track leading towards a brooch spire which recalls the steeple of St Mary's, Great Henny (fig. 27). In the foreground a fallen tree is silhouetted against the autumnal foliage – a variation of the device used for the central birch tree in *Drinkstone Park* (fig. 11). The fallen oak is cut to produce a framing device around two herdsman and three

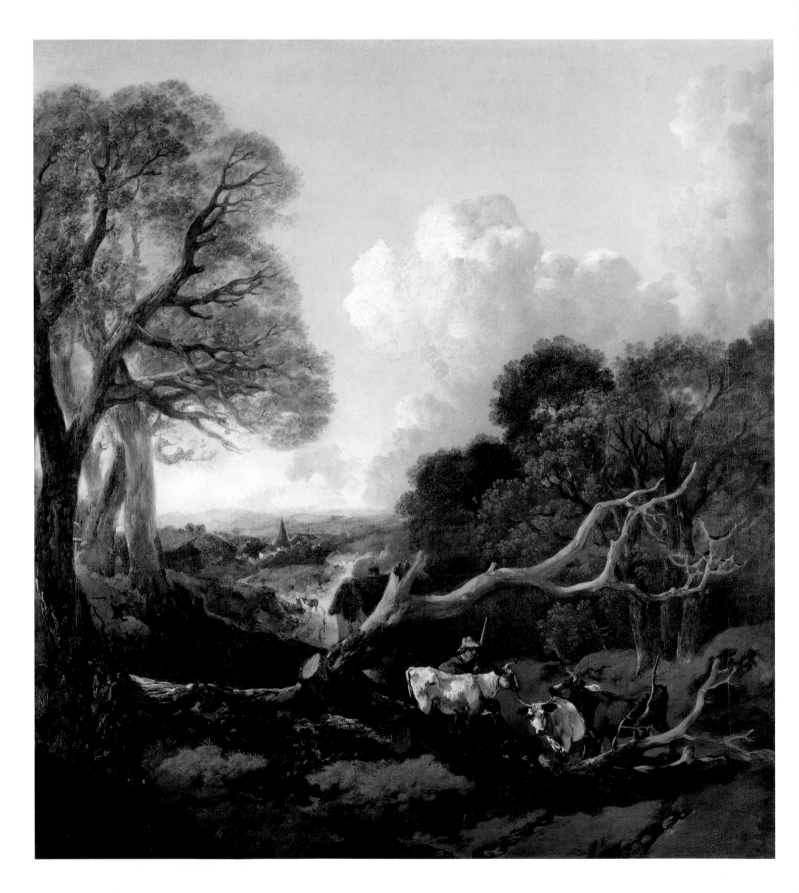

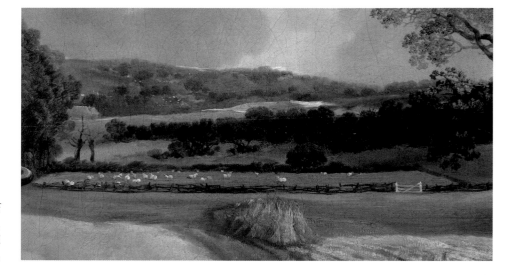

Fig. 27
Thomas Gainsborough,
The Fallen Tree,
c. 1750–53.

Detail of
Thomas Gainsborough,
*Portrait of Mr and
Mrs Andrews,* c. 1750.

Detail of
Thomas Gainsborough,
Portrait of Mr and Mrs Andrews, c. 1750.

cows. Once again the clouds bubble up to extend the foliage of the trees on the right in contrary motion to the fallen tree below. This provides Gainsborough with a liberating compositional element which allows him to play with the abstract pattern of branches, and provides him with a dominant subject for the painting. In this canvas there is an overall harmony of design and a unity of observation. No longer do veristic details (the burdock clump in the Muilman conversation piece for instance) jar with the rest of the composition. Detail has become subservient to the art of composition — but it has not yet turned to artifice.

Perhaps the greatest balance is achieved in the *Portrait of Mr and Mrs Andrews* (fig. 28). Robert Andrews was a year older than Gainsborough whom he would have known at school. He had married sixteen-year-old Frances Carter, whose parents had been portrayed by Gainsborough a few years earlier, on 10 November 1748 in All Saints' Church in Sudbury (the tower has been rendered visible by parting the trees in the centre of the canvas). As one might guess from the mutual detachment of the couple, the marriage was arranged. On her father, William Carter's, death in December 1748 a half-share of the Auberies estate was bequeathed to Robert Andrews, a legacy he eventually received after probate in 1750. Robert's father, also called Robert, had acquired the other half-share by bequest in 1717. The elder Robert, who had died in 1735, left his share to his son, but ensured his widow, Martha, a life interest in the house. She died early in 1749 and the property reverted to her son, Robert. In 1750 the two halves of the property were reunited and it seems likely that this event is commemorated in the double portrait. The unusual dimensions of the canvas suggest that the painting may have been intended as an overmantel and as such, it was a definitive statement of the union of property and marriage, which would be seen by every visitor to the house.

Robert Andrews is shown as a countryman in hunting coat, with dog and gun at his side. The most common interpretation of the unfinished gap on the

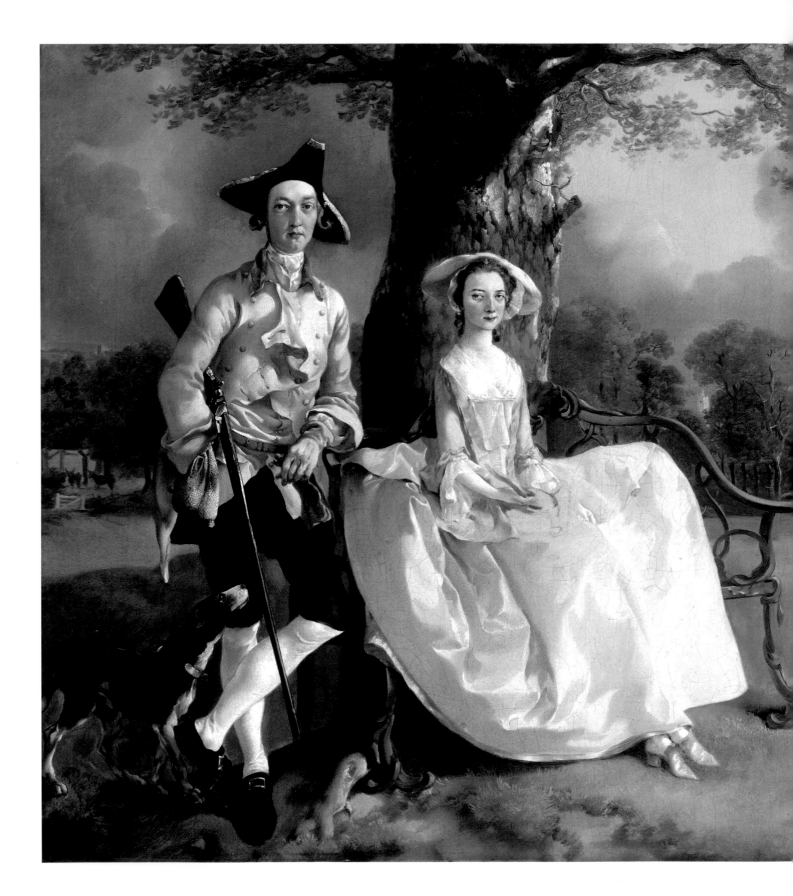

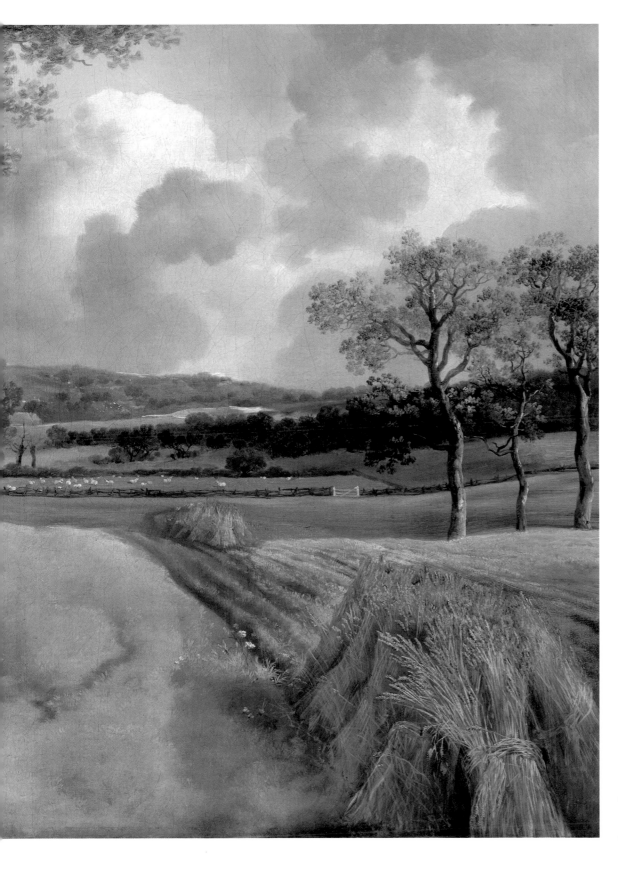

Fig. 28
Thomas Gainsborough,
*Portrait of Mr and
Mrs Andrews*, c. 1750.

lap of his wife is that her husband has given her a cock pheasant which he has just shot in one of the covers 'adapted for Field Sports'. To the right the wheat, which has been grown in straight rows through the 'spraining' method rather than by a seed drill, has been cut into sheaves.[21] However, the crop in the canvas is more lush than this particular land would allow. The fertility doubtlessly symbolised the anticipated fecundity of the marriage (the couple would have nine children before Frances Andrews's death in October 1780). To the right the design is closed by three young trees, which are more of a compositional construct than a topographical record, and beyond the wheatfield is a white five-bar gate (another is shown behind Robert Andrews) and a field of sheep enclosed by a wicker fence. These features anticipate the description of the estate when it was sold fifty years later as 'admirably disposed for the Purposes of Agriculture, which is here very skilfully practised, and is still in a State of rapid Improvement.'[22] Beyond the field of sheep, to the south-east, is a faithful rendering of the barns at Ballingdon Hall, the chalk pits at Middleton and the woods on the far side of the Stour valley at Cornard (see detail, top of p. 41). To the left, on the horizon five miles to the north, is the early eighteenth-century tower of Holy Trinity, Long Melford. It was unusual for Gainsborough to have chosen a background with so many topographical details, but, given the great interest that Andrews had in advanced agricultural thinking, the precise account rendered in the canvas is likely to have been the decision of the sitter. Perhaps because of these precise constraints Gainsborough was able to paint one of the most potent images of the eighteenth century.

Similar to the scene recorded more abstractly in *The Fallen Tree* (fig. 27), the whole landscape is made up of a series of lilting undulations which are echoed in the gentle curves of the elaborate park bench on which Mrs Andrews sits. The whole composition uses the great oak tree as its fulcrum with two white gates either side, and the darkness of the sky on the left balancing the lighter hues to the right. The browns and purples of distant Cornard Wood are repeated in the markings of the faithful hound; the colour of the dog's yellow collar reappears in Mrs Andrews' underskirt and the corn stooks to the right; and the apple green of the oak saplings is repeated in the velvet collar of Mr Andrews hunting coat. All these features, together with the unifying light, ensure that the couple sit *in* the landscape.

When compared to a painting by his contemporary, the Lancashire specialist in conversation pieces, Arthur Devis, the

Fig. 29
Arthur Devis,
Gentleman and Lady in a Landscape, 1747–49.

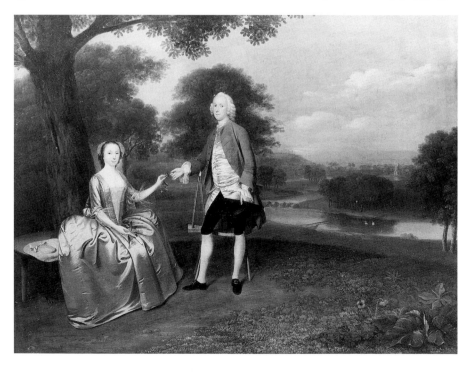

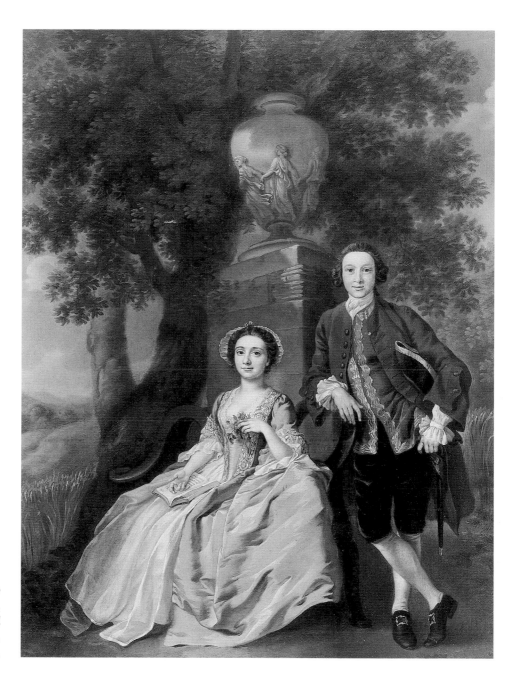

originality and spontaneity of Gainsborough's work becomes evident. Devis's marriage portrait of an unknown couple, painted in 1747 on a canvas of more conventional proportions, shows the wife seated beneath a tree on a simple wooden bench surrounding a tree trunk (fig. 29). She is handing her husband, who has been sitting with her on a garden chair, one of the sprigs of honeysuckle she has gathered in her lap. Honeysuckle symbolises the interdependence of their lives, and their gaze out of the painting makes the beholder a witness of their union. The backdrop landscape has skilful details such as the botanical studies in the right-hand corner which, like the field edge at the Auberies,

include poppies (see detail, bottom of p. 41). Unfortunately, as the identity of the figures remain unknown, it is impossible to link the background with any topographical view, but it has the air of an idealised landscape, a supposition which explains Devis's location of the tree which fortuitously surrounds the husband's head.

Another comparison, which possibly postdates the Andrews conversation piece, is the marriage portrait of George and Margaret Rogers by Francis Hayman which, in all probability, was painted for Mrs Rogers's father, Jonathan Tyers, in about 1751 (fig. 30). Given the close connection between artist and patron, it appears to be a more straightforward portrait than either the Gainsborough or the Devis. Like Robert Andrews, George Rogers adopts the cross-legged pose which was developed to show the assured confidence of the gentry, and his wife sits on a less expensive version of Mrs Andrews's garden seat. They pose beneath a tree and a classical urn decorated with the Borghese Dancers located on the edge of a garden beside a wheatfield. Both the wheatfield and the Dancers, whose performance was part of a classical marriage ceremony, indicate the purpose of this commission. Stylistically, however, in comparison with Gainsborough, Hayman's work seems clumsy and gauche. Nevertheless the young artist's development was hardly straightforward and the portrait of Robert and Frances Andrews is a remarkable achievement which shows the same concentrated response to prescribed commissioning as *The Charterhouse* (fig. 25). It also shows that in Suffolk, with the demands of a young family and presumably less ability to travel, Gainsborough had assimilated the various influences he was exposed to in London. *Mr and Mrs Andrews* has a confidence and unity about the composition which his earlier works lack; the different influences evident in the Muilman conversation piece energise the painting but also create tension in the composition. Perhaps Robert Andrews's detailed brief for the painting replaced any peer pressure the young artist experienced at St Martin's Lane and enabled him to find his own voice.

Gainsborough's work hardly developed in a linear way and the Andrews's portrait represents a huge leap in progress. As we will see in portraits such as the Gravenor family (fig. 33), the legacy from the Andrews's commission was a refinement of colour, but compositionally, and in other ways, he would not equal the poise of the canvas for another five years. To chart this progress it is worth comparing the painting with a portrait of an unknown man (fig. 31), shown seated on a bank, a perch which is none too easy to explain, especially as it is hidden by clump of mallow. He has just put aside his book, and his right arm is supported by a pedestal which provided him with a certain degree of comfort when he was reading. The handling of the features and the waistcoat resemble those in the Muilman conversation piece (fig. 16), but the unresolved landscape has closer affinities with the background of the *Man in a Wood with a Dog* (fig. 8). Compared to *Mr and Mrs Andrews* the figure is jarring, the colour ponderous and the detail gauche. As always, Gainsborough's solution was to return to nature to resolve these difficulties.

Fig. 31
Thomas Gainsborough,
Portrait of a Man,
c. 1747.

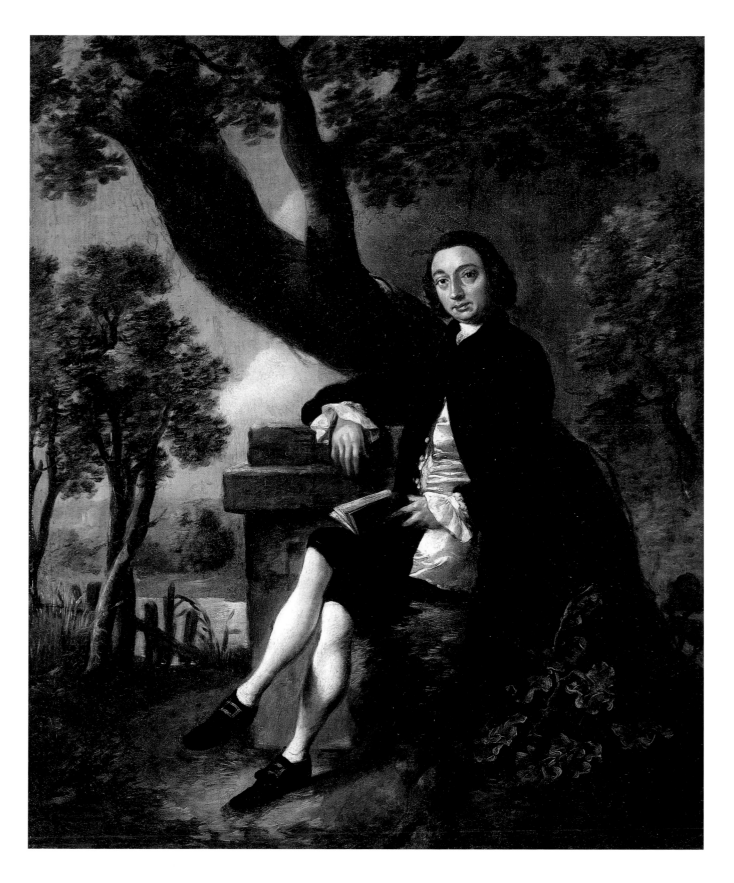

IV Portraiture in the Country

Although Sudbury provided familiar ground which formed Gainsborough's approach to landscape painting, it could never have provided the portrait commissions that would give Gainsborough a reasonable living. Maybe the annuity from the Beaufort estate encouraged bickering in the family rather than security. Whatever the reason, after three or so years, and perhaps as early as the autumn of 1751, Gainsborough took his family to Ipswich were he lived in Brook Street before renting a substantial house in Foundation Street from Mr Thomas Raffe, a grocer. Ipswich had been an important mediaeval port and had retained its position as a centre of communications which, to quote Daniel Defoe again, improved the intellectual life of the town (fig. 32). Defoe wrote in 1722: 'There is a great deal of good company in this town ... and I observed particularly that the company you meet with here are generally persons well informed of the world who have something very solid and entertaining in their society: this may happen perhaps by their frequent conversing with those who have been abroad'.[23] Thirty years later the town had a music club, a garrison at

Fig. 32
Samuel (1696–1779) and
Nathaniel Buck (d. 1774),
South-west Prospect of Ipswich,
1741 (detail).

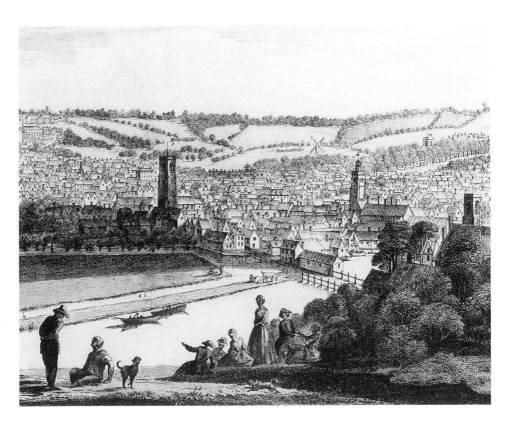

Detail of
Thomas Gainsborough,
Portrait of Sarah,
Mrs Tobias Rustat, c. 1757.
(see fig. 45, p. 68)

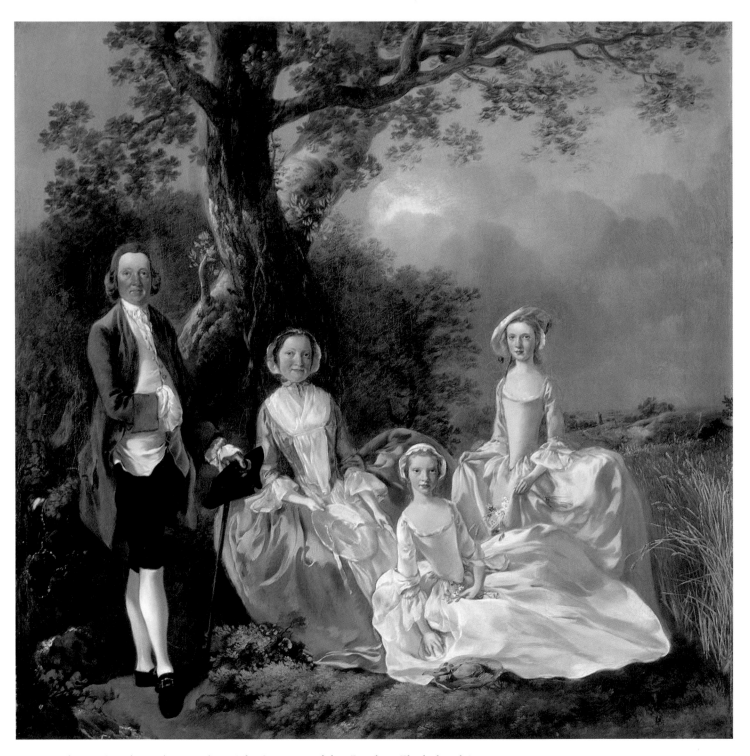

Fig. 33 Thomas Gainsborough, *Mr and Mrs John Gravenor and their Daughters Elizabeth and Ann*, c. 1754.

Landguard Fort ten miles to the east, a school of repute, theological debate amongst its many clerics, a town library and — during the artist's time there — a lively political life. Most importantly, it was a town that provided him with many more opportunities for portrait commissions.

Among his first sitters in Ipswich were John Gravenor and his second wife, Ann Colman, who are portrayed with their two daughters (fig. 33). Ann was the elder, and Elizabeth, the younger, is shown dressed in white, seated at her mother's feet. Gravenor was an Ipswich apothecary who became a town bailiff in 1754 and it has been suggested that this painting was commissioned to commemorate his election. Yet again figures are shown on the edge of a wheat field with a distant view on the right focusing on a church tower. Behind the couple are two tree trunks crossing which, like the honeysuckle, is an indication of their intertwined lives. On the extreme left a spring flows, which appears compositionally unnecessary and may have some iconographic significance which has now been lost. Although technically the paint sparkles and the handling of the three dresses — shimmering blue, white and pink — is of exceptional quality there is a blandness about the heads; similarly, the list of the figures to the left gives a distinctly uneasy air. It is tempting to attribute this defect to the slavish use of a lay figure and, if this is so, it suggests that Gainsborough's interest was focussed on the composition rather than the purpose of portraiture, which he was later to define as the achievement of a good likeness. At the same time as this composition he produced a few head-and-shoulder portraits.

The companion portraits of John Vere (fig. 34) and his wife Mary (fig. 35) also date from the artist's first years in Ipswich. The Veres had an estate at Henley, four miles to the west of the town, although John's father, Thomas (another Gainsborough sitter), spent more time at Thorpe, a property outside Norwich. Both figures are shown framed in feigned stone ovals which are sculpted like œil-de-bœuf windows in a façade by Wren, and are reminscent of the elaborate frames that Gainsborough was helping Gravelot to design for Houbracken's *Illustrious Heads* ten years earlier. It was an approach, perhaps derived from miniature painting, which had been introduced in the eastern counties by the *émigré* Dutchman, Cornelius Jannsens, and which Gainsborough used in other portraits of the Veres' neighbours. The portraits, with a buttery handling of the paint, shows the same straightforward approach to painting the human face as we found in his paintings of the 'first imatations of little Dutch Landskips'. Mrs Vere wears blue pendant earrings which match the blue ribbon around her neck and which decorate her stomacher. She wears a severe, cropped hair style, which first appeared in the early 1750s, pulled back from the forehead and decorated with silk flowers. The two portraits were clearly intended to be hung together but what is curious is the difference in colour of the sculptural surrounds: John Vere's has a much greener tone. Not knowing the original position of the portraits, it is interesting to speculate whether this difference was designed to compensate for the different quality of light falling on the two portraits.

Following pages:

Fig. 34
Thomas Gainsborough,
Portrait of John Vere, c. 1752.

Fig. 35
Thomas Gainsborough,
Portrait of Mary, Mrs John Vere, c. 1752.

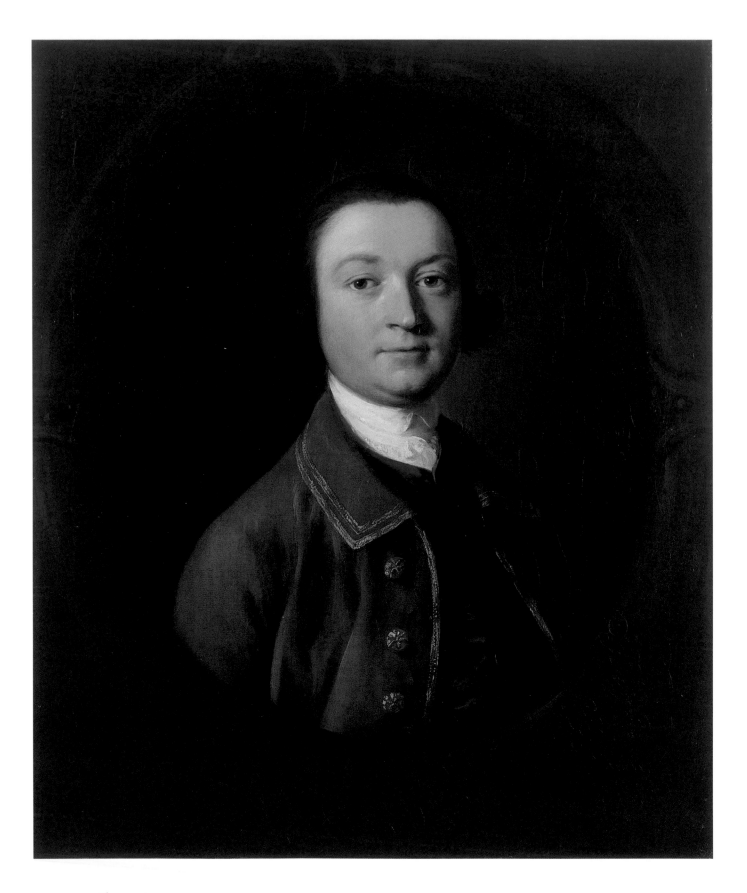

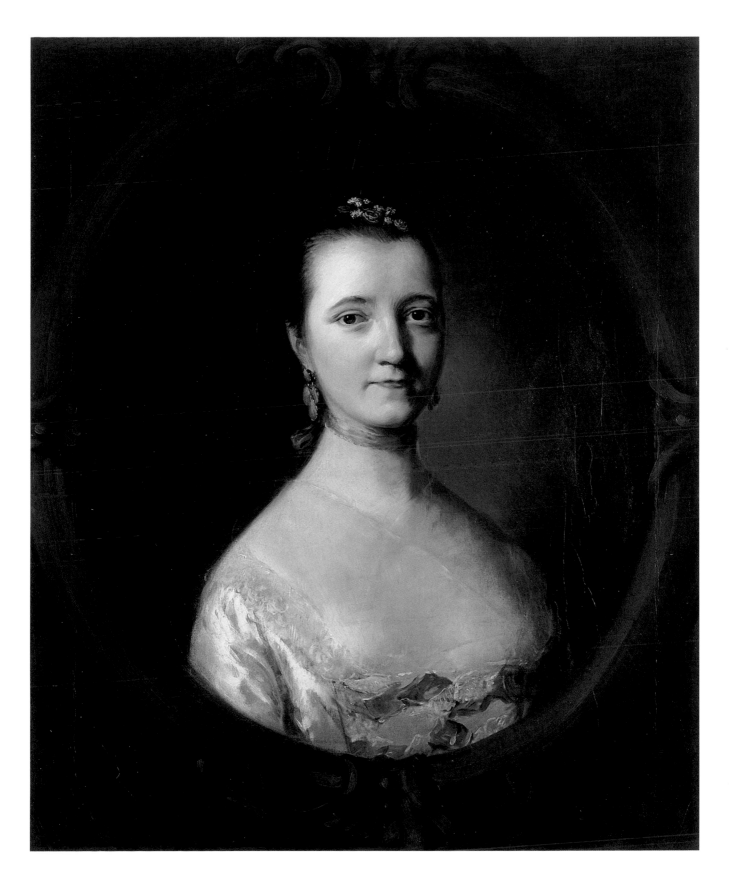

Among the friends that Gainsborough made soon after he moved to Ipswich was Philip Thicknesse, the Lieutenant Governor of Landguard Fort. The fort had originally been built on the north bank of the River Stour in the 1540s to protect the Essex port of Harwich. It had seen action in the Second Dutch War of 1666 which resulted in a series of improvements to the defences over the next hundred years. Philip Thicknesse was appointed in February 1753 and, shortly after, he commissioned an overmantel from Gainsborough (fig. 36). He described the commission thus: 'I desired him [Gainsborough] to come and eat a

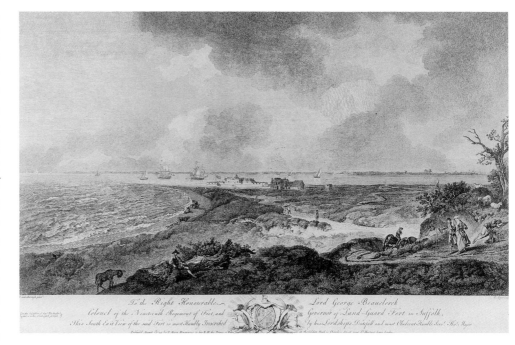

Fig. 36 Thomas Major after
Thomas Gainsborough, *Landguard Fort*, 1754.

dinner with me, and to take down in his pocket book, the particulars of the Fort, the adjacent hills, and the distant view of Harwich, in order to form a landscape of the Yachts passing the garrison under the salute of the guns, of the size of a pannel over my chimney piece, he accordingly came, and in a short time after, brought the picture [which Thicknesse bought for] … fifteen guineas'. Thicknesse continues: 'The following winter, I went to London, and … took it with me, and as Mr. Major the Engraver, was then just returned from Paris … I shewed it to him; he admired it so much, that I urged him … to engrave a plate from it … but alas! the picture, being left against a wall which had been made with salt water mortar, is perished and gone.'[24] The plate is dedicated to Lord George Beauclerk, the Governor of the Fort, in a toadying gesture that was characteristic of Thicknesse. The print itself, however, is worth analysing in some detail.

In the middle ground the fort and Thicknesse's cottage, the subject of an etching by Gainsborough (see p. 92), is shown in the centre with yachts and ships passing up and down the smooth waters of the Stour estuary on the right. Harwich is shown on the far bank. To the left are the choppier waters of the open sea with cows grazing on the foreshore. Above, a dramatic sky compensates for the strong horizon. A sandy road takes the eye along the spit to the fort and in the foreground 'the adjacent hills', bitten more strongly in the plate, are populated with Gainsborough's usual staffage. On the right is a sleeping shepherd, adopting a pose which is frequently used by Gainsborough at this time, and a few sheep; a pair of lovers walk down the track following a cart which, like the cow in the Philadelphia landscape of 1747 (fig. 14), is just disappearing over the brow of the hill. To the left a donkey in profile brings the eye into the composition and a man disports himself on a tree trunk with legs splayed in a pose which has been traced back to Antoine Watteau and was adopted by both

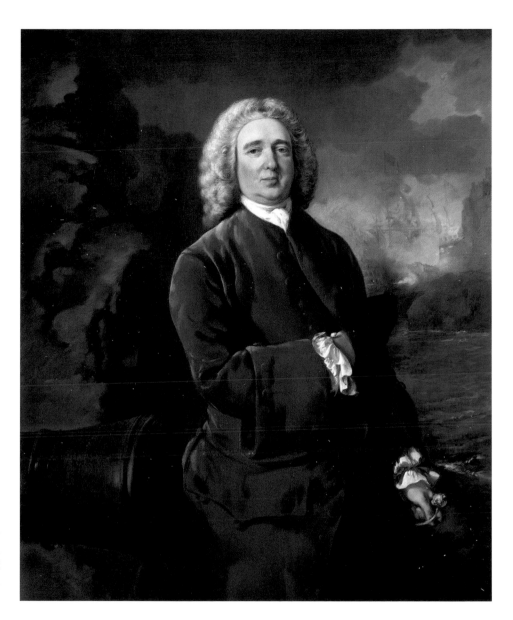

Francis Hayman and by Gainsborough in his portrait of John Plampin (now in the National Gallery, London). It suggests relaxation, contentment and ease with the rural idyll and, in this print, it is tempting to identify the figure as Thicknesse himself, though if this were so, it is surprising that he failed to mention the fact in his own description of the painting.

Gainsborough's most prestigious commission at the time was a three-quarter-length of Admiral Edward Vernon (fig. 37). Vernon, 'a remarkably brave man, sober well experienced, and zealous for the honour and interest of his country', become a national hero in 1740 after capturing Porto Bello in the West Indies from the Spanish. Soon after his return to England he was elected to sit in the House of Commons for Ipswich. His popularity appeared to go to his head and he made a 'frantic speech' in the House through which 'he had worn out even

laughter'. Although raised to the rank of Admiral, he was soon in dispute with the Admiralty and foolishly he allowed his letters of criticism to be published, which resulted in Vernon's dismissal from the service. His bombastic approach to the Commons eventually made his fellow members 'sick of his noise' and by the time Gainsborough painted him he was able to maintain little credibility anywhere but Ipswich.[25] This may go some way to explaining the otherwise extraordinary choice by a national hero of seventy of a twenty-five-year-old to paint his portrait. As a Member of Parliament there would have been easy access to the studios of London artists, but instead he chose Gainsborough.

Vernon is shown beside a rocky outcrop with the muzzle of a cannon beside him and the onslaught on Porto Bello raging in the background. The sitter wears a brilliant red coat which brings together the red-brown of the outcrop and the orange of cannon fire. His right hand, as in so many mid-eighteenth-century portraits, is inside his waistcoat, while his left holds the hilt of a sword and he has a self-congratulatory glint to his eye. The buttery quality of the paint in the head recalls the treatment of the faces of John and Mary Vere, but the handling of the velvet coat has not been seen before in Gainsborough's work. The delineation of the powdered wig recalls the wig worn by Gainsborough's father (fig. 26) and it was scrupulously copied by James McArdell when he made a mezzotint of the painting for Vernon to distribute amongst his friends and supporters. Vernon must have been pleased with the canvas as a second autographed version of the painting, now in the National Portrait Gallery in London, was also commissioned. Thicknesse saw the portrait with others in Gainsborough's Ipswich studio and felt his work was 'truly drawn, perfectly like, but stiffly painted, and worse coloured'. Nonetheless, Gainsborough remained loyal to his local clientele and continued to paint portraits on the scale of conversation pieces, a format which, in the context of London practice, was looking decidedly old-fashioned.

The narrative elements in Gainsborough's portrait of Major John Dade are unusual and something which he never developed in his work (fig. 38). Dade, who was to become a major in the East Suffolk Militia, lived at Tannington near Framlingham north of Ipswich and was probably introduced to Gainsborough by their mutual friend, Samuel Kilderbee, a lawyer who, in 1755, became the Town Clerk of Ipswich. The painting shows a groom attending Dade's horse beyond the gate in the background. Meanwhile, the sportsman reloads his gun after shooting an English partridge. One of the dogs sits at his side having retrieved the game; the other catches its scent and approaches the dead bird with interest.

By the time Gainsborough painted Dade he was interested in using the landscape background to support the sitter rather than just provide a framework for the painting; this was something that he would develop with great effect in full-size portraits that he painted later in his career, but without the narrative of the Dade portrait. In the case of the Dade canvas, the sitter's head has been subtly silhouetted by the tree, and the gap between the right-hand profile of the figure and the tree trunk provides a touch of sophistication. Compared to the handling

Fig. 38
Thomas Gainsborough,
*Major John Dade
(1726–1811) of
Tannington, Suffolk,*
c. 1754.

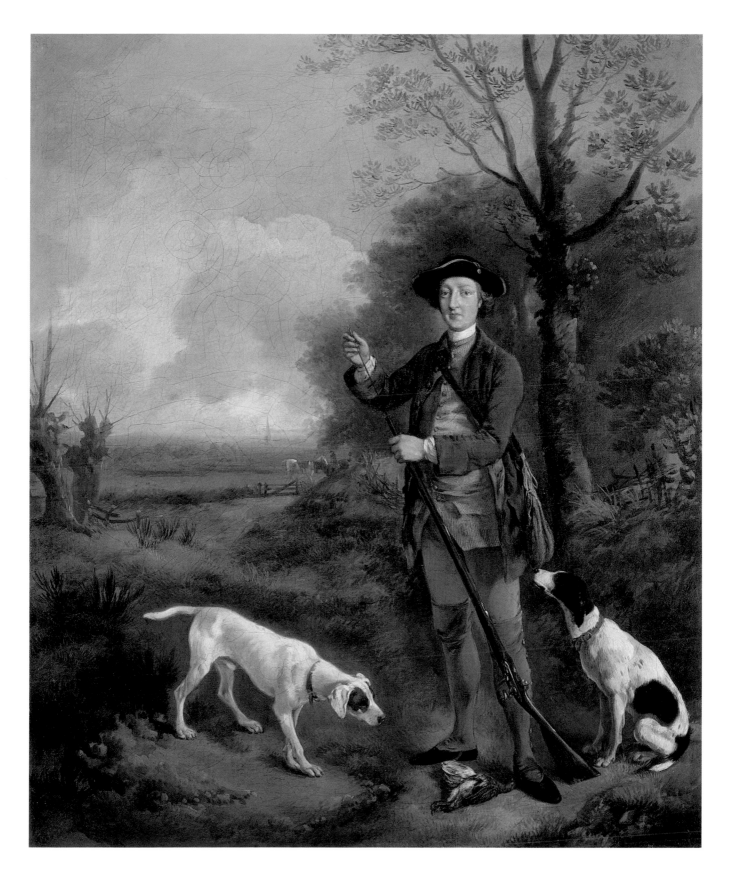

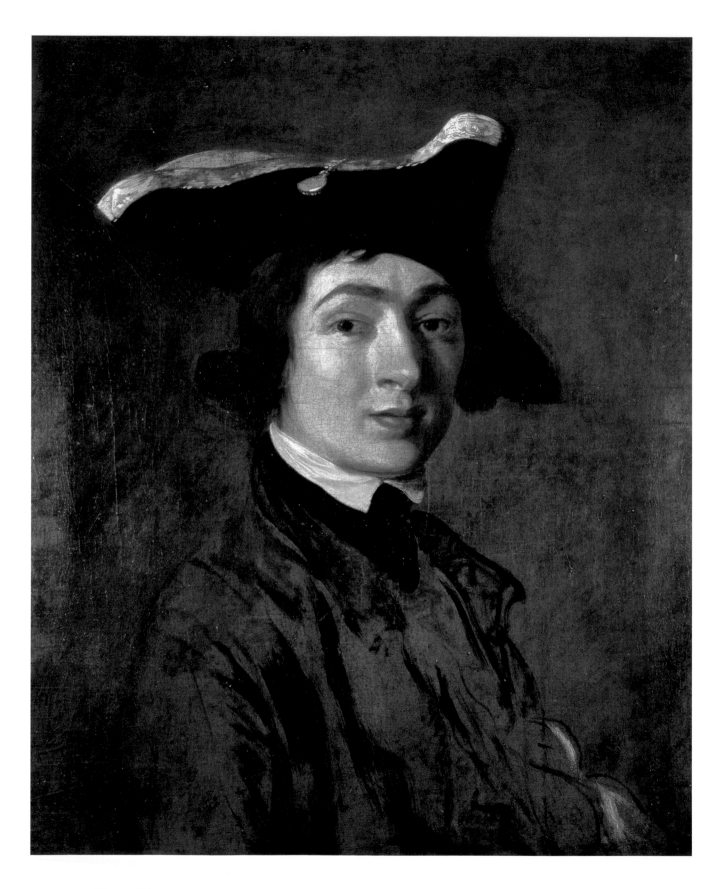

of the paint in the Andrews's conversation piece, the Dade portrait is looser. Areas such as the bush on the extreme right are only sketched in, encouraging the eye to return to the main subject of the painting. As Gainsborough is beginning to use different levels of finish in his canvases, it is worth examining an unfinished work to gain a little more understanding of his technique.

A self-portrait from the same period bears an inscription on the back: 'Painted by Thomas Gainsborough at Ipswich about the year 1754 (2nd sitting of himself) aged 28' (fig. 39). The whole composition has been drawn at lightning speed in black paint, and only the head and tricorn hat, worn at a rakish angle, are complete. The coat, with the left hand tucked into the waistcoat and a flash of white for the cuff, has been left as little more than an outline. In addition to this canvas there are a number of unfinished landscapes from the same period and they all show that the artist maps out the complete composition first of all, before bringing areas of the canvas to a high finish. Later in his career there was an intermediate stage of blocking in the main colours in a semi-darkened studio to create a tonal balance in the composition. The 1754 self-portrait shows the artist's assured sense of line and his technical brilliance. It should never be forgotten that, as one modern commentator has written, Gainsborough needed to draw in the same way that others need to sing.[26] He was continually recording his visual experiences and by doing so fixing them in his memory for future use. As we have already noted, in a number of works, Gainsborough's heightened awareness of balance and tonal values, nurtured in tandem with the exquisite draughtsmanship, enabled him to correct and change his work as it developed on the easel.

In 1754, as has already been surmised, with Gainsborough asking no more than five guineas for a head-and-shoulders portrait, his contribution to the family budget was small. But the lack of commissions had its compensations and it allowed him to have time to develop his interest in music. He was an active member of the Ipswich Music Club and made friends with professional musicians, such as Joseph Gibbs, the organist at the civic church of St Mary Tower, and amateurs such as John Wood, a dancing master, Captain Abraham Clerk and John Mills all of whom appeared with Gainsborough in a witty group portrait of their music making which has sadly been lost.[27] He also had time to investigate the possibilities of etching and, with the help of Thomas Major the small print of Thicknesse's cottage may have been his first successful experiment with the medium.

More, however, is known about a landscape print, *The Suffolk Plough*, which reproduces a painting he produced at this time and is etched in reverse (fig. 40). His impatience with the technique caused him to leave the plate in the acid for too long, and, after taking a few trial proofs, he destroyed the plate. In a further attempt, *The Gipsies*, he copied a painting which he had made for an Ipswich client and took a number of trial proofs so that it is able to chart the changes in design as the plate progressed. Realising its potential Joseph Wood (a colleague of Joshua Kirby) made a number of further improvements publishing the completed design with considerable success in 1759.[28]

Fig. 39
Thomas Gainsborough,
Self-portrait, 1754.

Nonetheless drifting from commission to commission, as and when they appeared, was hardly a way forward. Gainsborough must have seen the request to paint two overmantels for the Duke of Bedford as a major breakthrough. In the mid-1750s John, 4th Duke of Bedford, redecorated a suite of rooms at Bedford House in Bloomsbury and the western range of Woburn Abbey. The weight of evidence suggests that the two overmantels commissioned from Gainsborough were a contribution towards the decoration of the state rooms on the west front of Woburn. They may have been painted for either the chimney piece in the principal saloon, which was provided by John Rysbrack (his bill is dated 29 May 1756), or for one of the chimney pieces which John Deval sculpted for the hall, gallery and state rooms in 1755 and 1756. The measurements of an overmantel, which may have been moved, on the ground floor of the west wing at Woburn directly corresponds to the dimensions of one of the paintings. It is a mystery why Bedford should have chosen Gainsborough, although twelve years earlier he had commissioned work from George Lambert, who, as a close associate of Hogarth, would have been known to Gainsborough during his time in London. Another possibility, perhaps more likely, is that the Duke had admired the Charterhouse roundel at the Foundling Hospital and decided to commission such a lively talent.

What is uncharacteristic about both the Bedford landscapes is the relative size of the figures to their surroundings; they are very much more than 'a little

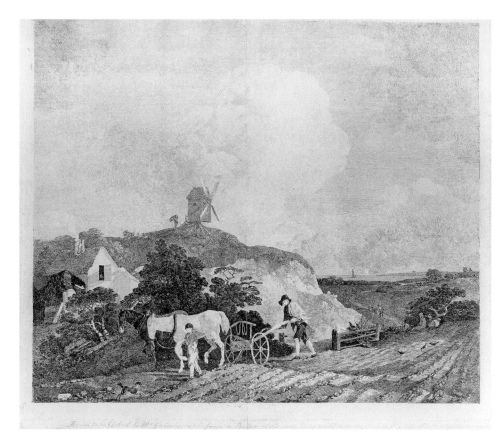

Fig. 40
Thomas Gainsborough,
The Suffolk Plough, c. 1754.

Fig. 41
Thomas Gainsborough,
*Landscape with a Woodcutter
courting a Milkmaid*, 1755.

business for the eye' and take on the mantle of the subject in each canvas. In the *Landscape with a Woodcutter courting a Milkmaid* the two main figures pose beneath the hollow trunk of an ancient pollarded oak (fig. 41). The maid has half finished her task, unbuttoned her overdress and sat down with a pail full of milk; the other bucket awaits her attention beneath the cow with the upturned milking stool beside it. The maid has been disturbed by a woodcutter who seems to be pointing to the object of his desire rather than the wooden dish that the girl holds. In response she turns her head away and, as so often in painting, the animal, in this case the white cow, takes on an empathetic restlessness. There is a clear risk of the milkmaid not only spilling the milk but losing much else

besides. To the left, behind a carefully constructed gate and used as a foil to the diagonal movement of the lovers, is a working plough team. In the background giving, as Michael Rosenthal has noted, a sense of time and place as well as a puff for the artist, is a distant view of Ipswich.[29] It has also been suggested that, like the conceits in *Cornard Wood*, the two contrasting activities in the painting are emblematic of those associated with common and enclosed land.

A similar theme, showing earlier stages of seduction, appears in paintings formerly in the Jennings and Howe collections, the Montreal Museum of Art, and in a painting only known through the print published by François Vivares in March 1765. Interestingly all these compositions have prominent aged trees as a backdrop. The Montreal canvas was reproduced by Vivares in a print entitled *The Rural Lovers* which was marketed in both England and France and gained popular appeal when the central motif was reproduced as a transfer print used to decorate china from factories in Worcester, creamware produced by Wedgwood and pottery manufactured in Liverpool.[30]

The other canvas painted for the Duke shows a lad, dressed like the lover in the other landscape, riding bareback and leaning on the neck of a white mare while another horse rest its head on her flank (fig. 42). All three are sheltering from the summer sun beneath a tree, snatching a moment's rest between pulling carts of hay. In contrast to the relaxation of the foreground scene, two labourers in the background are loading a haywain beside the village pond. Local characters

Detail of Thomas Gainsborough, *Landscape with Peasant and Horses*, 1755.

Detail of Thomas Gainsborough, *Landscape with a Woodcutter courting a Milkmaid*, 1755.

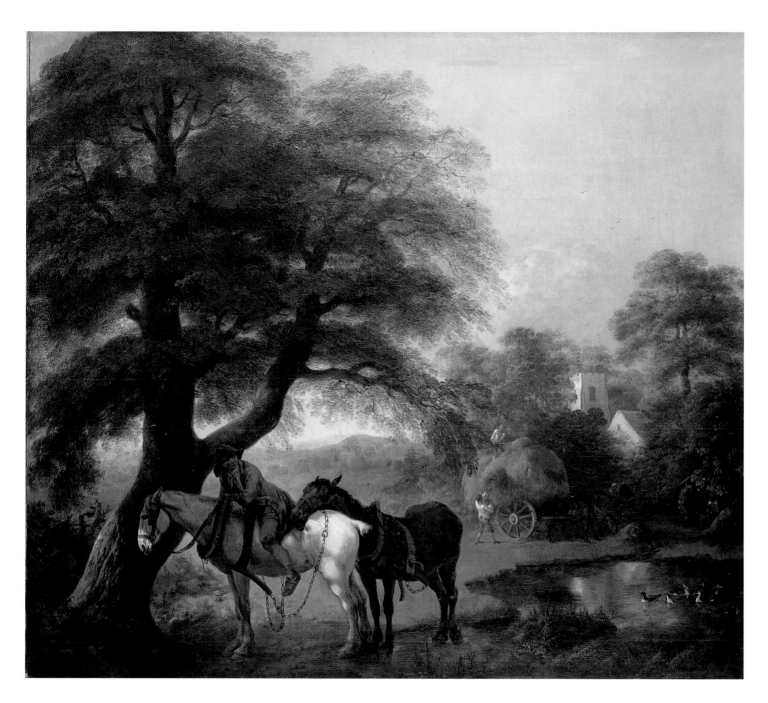

Fig. 42
Thomas Gainsborough,
Landscape with Peasant and Horses, 1755.

swap tales as they lean on a gate separating the meadow from the seemingly omnipresent church and farm.

There can be little doubt that Gainsborough rose to this important commission. The compositions are carefully considered and the high finish of each painting provides the liveliest of details such as the ducks on the ponds and the heads of cow-parsley growing beside the pollarded trunk. Perhaps the relatively high charge of £21 and fifteen guineas paid for the two canvases respectively reflects the amount of time and care Gainsborough spent on the commission.

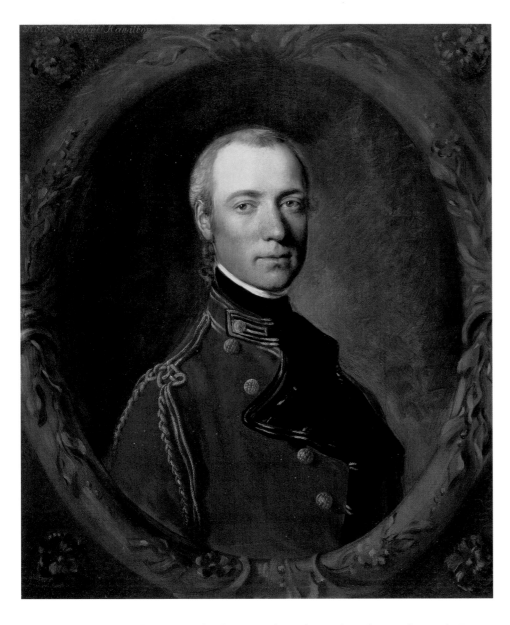

Fig. 43
Thomas Gainsborough,
Portrait of Hon. Charles Hamilton,
c. 1756.

The portrait of the Hon. Charles Hamilton dressed in the uniform of a Lieu-
tenant Colonel in the First Dragoon Guards is portrayed with a similar direct-
ness (fig. 43). He sits behind an elaborate feigned oval looking directly at the
beholder. Gainsborough has obviously taken pleasure in recording the irregu-
larities of the plaited rope around his arm and the complex lapel of his coat.
There is also a dissimilarity in the broad handling of the cartouche and the
details of the head, with the flecks of white paint highlighting the hair and
moistening the eyes. The First Dragoon Guards were stationed at Landguard
Fort and provided at least one other sitter to Gainsborough in a portrait, now
lost, signed and dated 1756.[31]

The intensity of the paintings of this period is perhaps best seen in the out-
standing double portrait of Gainsborough's two daughters, shown hand-in-hand

playing beneath an overcast sky on the edge of a wood (fig. 44). The younger daughter, Margaret, is rushing forward to catch a butterfly, a female cabbage white, which has settled on a thistle. The elder daughter, conscious of the painful prickles, is less curious and prefers to disturb it with a nudge of her apron. Their moods and actions are perhaps best expressed in their hands. Margaret, the younger daughter, nicknamed 'the Captain' by her father, prepares to grab the butterfly with awkward outstretched fingers, while the hand of her sister, Mary or 'Mol', is more reassuring and stronger.

By studying the angle of the wings lepidopterists have established that the butterfly was dead when the artist painted it. So Gainsborough had at least one sitter who was static, and thus he was able to make an accurate portrait of the insect. For the children he relied on the myriad incidents he had observed during their upbringing. The painting can have been made for no one but Gainsborough himself, and is the first in a group of portraits of his daughters which chart their development from vulnerable and curious children to marriageable young ladies, all painted with an understanding and affection that only a father could bestow. It is one of the most remarkable portraits of the eighteenth century: informal, loving, perceptive and intensely moving.

The handling too is exceptional. Gainsborough dresses his daughters in tones which blend with the background landscape: his elder daughter is in a dull yellow dress and her younger sister wears a grey-green skirt. This places extra emphasis on the faces and their expressions. Margaret's apron, swept back with her sudden movement, is an extraordinarily virtuoso touch which uses the pink ground of the canvas dappled with white (in different concentrations) and black to provide every nuance of the fall of the cloth. It shows a very sure understanding of the qualities of light and shade.

The number of landscapes produced at this time, the time spent painting his daughters, and developing his interest in etching and music-making implies a lack of commissions, and indeed by the mid-1750s Gainsborough appears to have fallen into debt. In 1756 he writes of having '3 Debts standing against me one of them 6 pounds odd' and another, to Lambe Barry, appears to have been settled by painting a portrait, a small-scale likeness showing Barry in hunting dress holding a whip with a dog by his side.[32] Perhaps Gainsborough's financial difficulties encouraged him to seek with greater energy clients who could make him solvent again. In this he was successful and he began to paint a number of head-and-shoulder portraits which, apart from providing income, served as an intensive training course in how best to achieve a good likeness. To create such uncompromising realism, sitter and canvas must have been placed the same distance away from the artist, and as a result these portraits have an intensity of observation and straightforward honesty worthy of any passport photograph.

The best-known portrait in the group is that of the Reverend Richard Canning (Ipswich Museums and Galleries) which was painted for the Reverend Henry Hubbard, a close friend since university days, who in turn gave Canning

Detail of Thomas Gainsborough, *The Painter's Daughters chasing a Butterfly*, c. 1756.

a portrait of himself (Emmanuel College, Cambridge). A list of Hubbard's possessions records the gift as taking place in 1757, which is presumably the date of the portrait. In technique it is very similar to the portrait of the Reverend Tobias Rustat (fig. 46) which was painted with a pendant of his wife, Sarah Paige (fig. 45). The flesh tones of all three clergymen are built up with striations of colour which would be especially telling in candlelight: the flickering of candles would enliven the uneven brush strokes and give the portrait greater animation. Concern about achieving a good likeness, 'the principal beauty & intention of a Portrait' as the artist wrote in a letter some fifteen years later, was of paramount concern and the frozen qualities of portraiture presented very particular problems. In the same correspondence he shows his concern: 'But only a face, confined to one View, and not a muscle to move to say here I am, falls very hard upon the poor Painter'.[33]

Gainsborough's new 'rough manner' may also have been influenced by pastel portraits by the Italian Rosalba Carriera and the Frenchmen Jean-Baptiste Perroneau. It is worth noting that at least one portrait by Perroneau, which was popularised in a mezzotint by Valentine Green, is recorded in an East Anglian collection, that of Lord Rochford, who, as will be noted below, was the elder brother of one of Gainsborough's patrons. The technique, however, caused some discussion with his clients. Early in 1758, in a letter written to a Colchester attorney, William Mayhew, who had sat for a portrait the previous year, Gainsborough notes his change in fortune and apologises for his absence. But, he says: 'Business comes in, and being chiefly in the Face way, I'm afraid to put people off when they are in a mind to sit'. Mayhew was uneasy with the 'roughness of the surface' of his portrait and Gainsborough explains that it was 'use in giving force to the effect at a proper distance, and what a judge of painting knows an original from a copy by; in short being the touch of the pencil [the eighteenth-century term for brush], which is harder to preserve than smoothness'. He continues: 'I don't think it would be more ridiculous for a person to put his nose close to the canvas and say the colours smell offensive, than to say how rough the paint lies; for one is just as material as the other with regard to hurting the effect and drawing of a picture'.[34] The same virtuosity of handling can be seen in the lace in Mrs Rustat's *fichu*, and the delineation of the silk bow at her breast. It is worth remembering that with the wealth of the Gainsborough family firmly based on the marketing of cloth, frequent conversations considering the relative qualities of stuffs must have helped Gainsborough's understanding of materials and textures, as well as persuading two of his sisters to become milliners.

Although the majority of his sitters commissioned straightforward head-and-shoulder portraits, some richer clients followed Vernon and commissioned three-quarter lengths. Perhaps the most surprising of these is the portrait of the Hon. Richard Savage Nassau of Easton Park, near Saxmundham, a past Member of Parliament for Colchester, whose brother was the 4th Earl of Rochford (fig. 47). Rochford returned from the envoyship at Turin in 1755 and, through

Fig. 44
Thomas Gainsborough,
The Painter's Daughters chasing a Butterfly,
c. 1756.

Following pages:

Fig. 45
Thomas Gainsborough,
Portrait of Sarah, Mrs Tobias Rustat, c. 1757.

Fig. 46
Thomas Gainsborough,
Portrait of Revd Tobias Rustat, c. 1757.

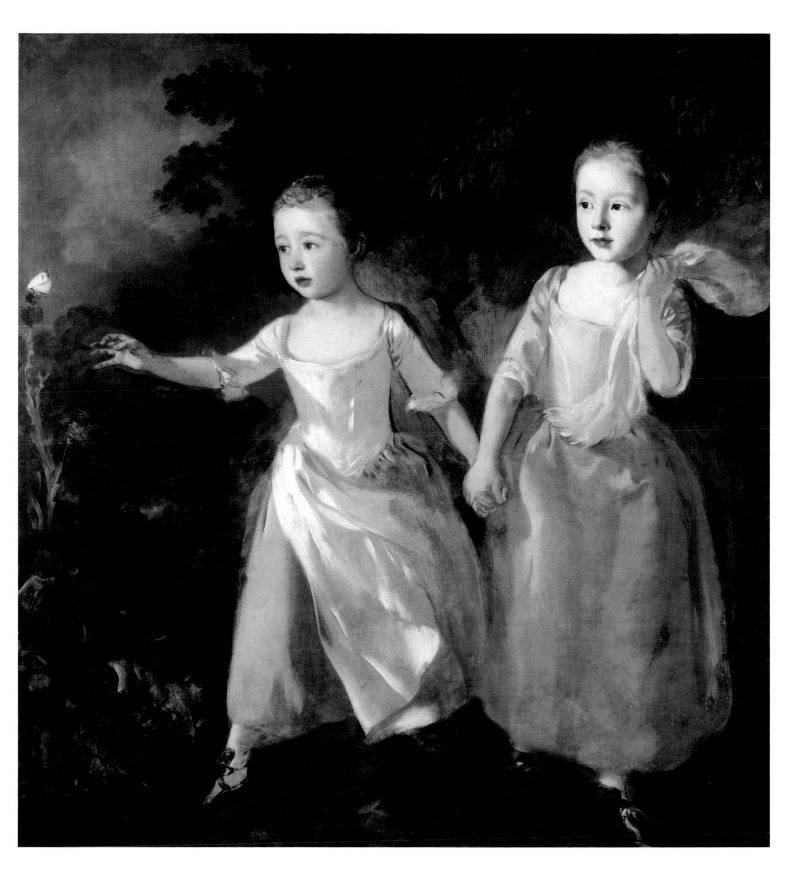

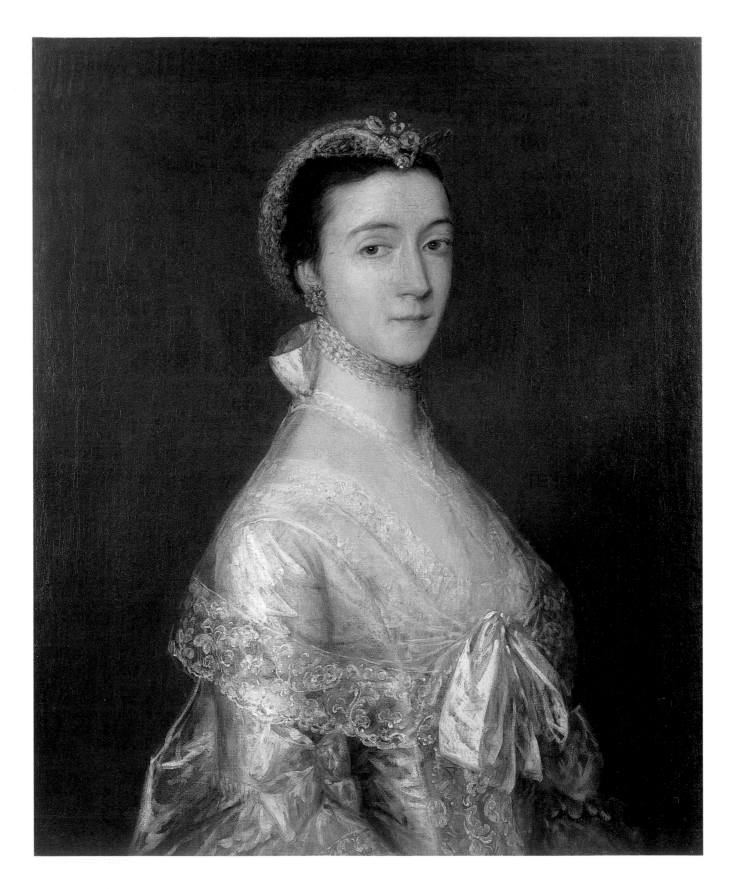

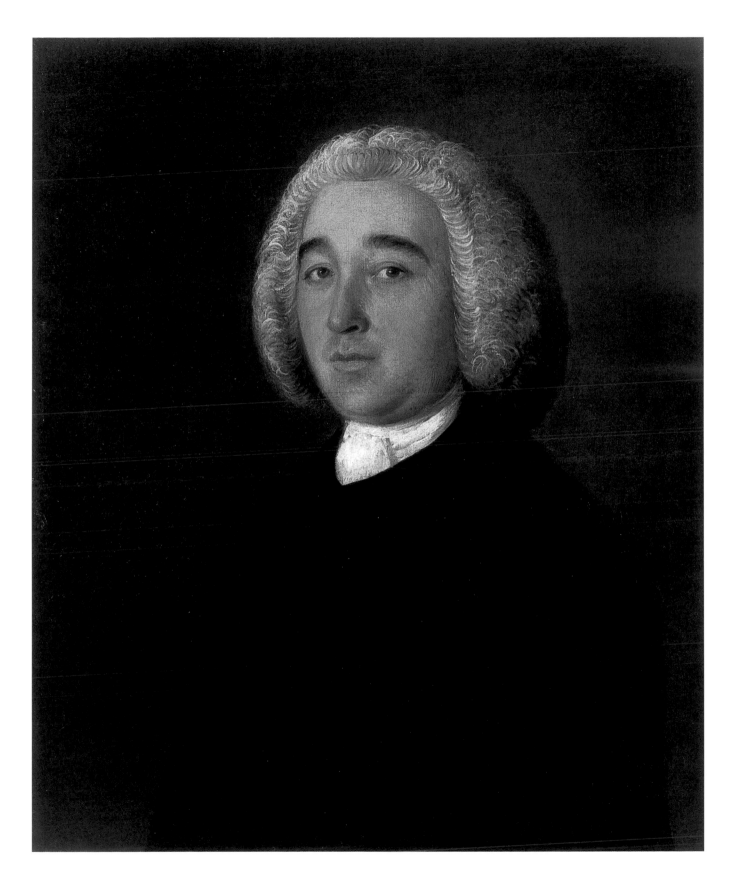

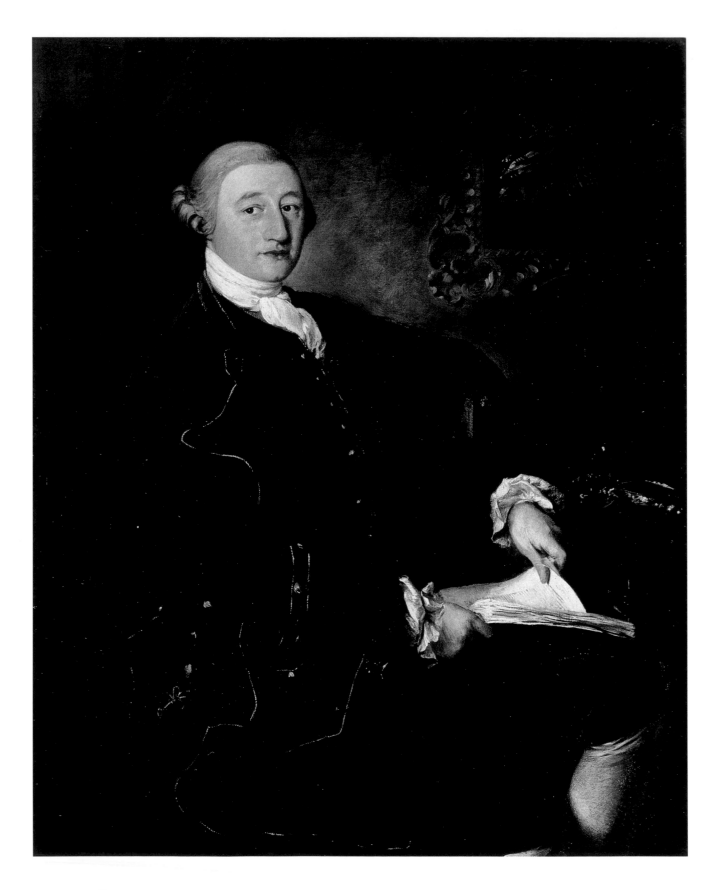

his Governorship of the Foundling Hospital, he may have been beguiled by Gainsborough's *Charterhouse* and thus encouraged his brother to commission the portrait. The canvas shows Nassau, his elbow hooked over the back of the chair, in a green coat edged with gold piping with a sword on the table, indicating his status as a gentleman. There is a glimpse of a landscape painting, a rather indiscreet advertisement, hanging on the background wall. Although the pose was rehearsed in a drawing, it lacks the ease of the other three-quarter-length portrait painted in the late 1750s.[35]

Gainsborough must have been equally encouraged by the commission from John Sparrowe, the owner of the Ancient House on the Butter Market in Ipswich and a bailiff of the town no less than thirteen times. Gainsborough showed him cross-legged, seated at a desk, his left hand resting on a book with a quill and legal tome ready beside him, and a dog's head added to show the civility of the sitter (fig. 48). Sparrowe turns his head towards the beholder in the anticipation of some sort of dialogue. The portrait is less busy, less contrived than that of Nassau with a green curtain draped on the right which takes the place of the Gainsborough landscape. The portrait also has an informality, attributed by John Hayes to its similarity to Allan Ramsay's portrait of John Sargent (Holburne Museum of Art, Bath),[36] which is lacking in the stiffly posed portrait of the bombastic Vernon painted five or so years earlier.

Gainsborough's concentrated work producing portraits had taught him to catch a good likeness — something that was only of passing concern in the small-scale of conversation pieces he had produced earlier in the decade. The success made him appreciate the pressures of a busy portrait practice and it also made him realise his own potential. It can be no surprise that he wished to test this further by travelling to Bath in October 1758, where he apparently stayed for at least six months. There he was able to put his hard-earned experience to work. The poet William Whitehead writes about him with considerable insight in a letter dated 6 December in Bath: 'We have a Painter here who takes the most exact likenesses I ever yet saw. His painting is coarse and slight, but has ease and spirit. Lord Villiers set [*sic*] to him before he left Bath, & I hope we shall be able to bring his Picture to town with us, it is he himself & preferably in my opinion to the finest unlike picture in the Universe, tho' it might serve for a sign. He sate [*sic*] only twice. The Painter's name is Gainsborough.'[37]

The portrait of Lord Villiers and the portrait of his father, Lord Jersey, was probably painted at the same time. Later on, when the inveterate gossip, Mrs Delany, visited the studio on 23 October 1760 and commented about the portrait of Miss Ford (fig. 62), she mentioned that Gainsborough had also painted

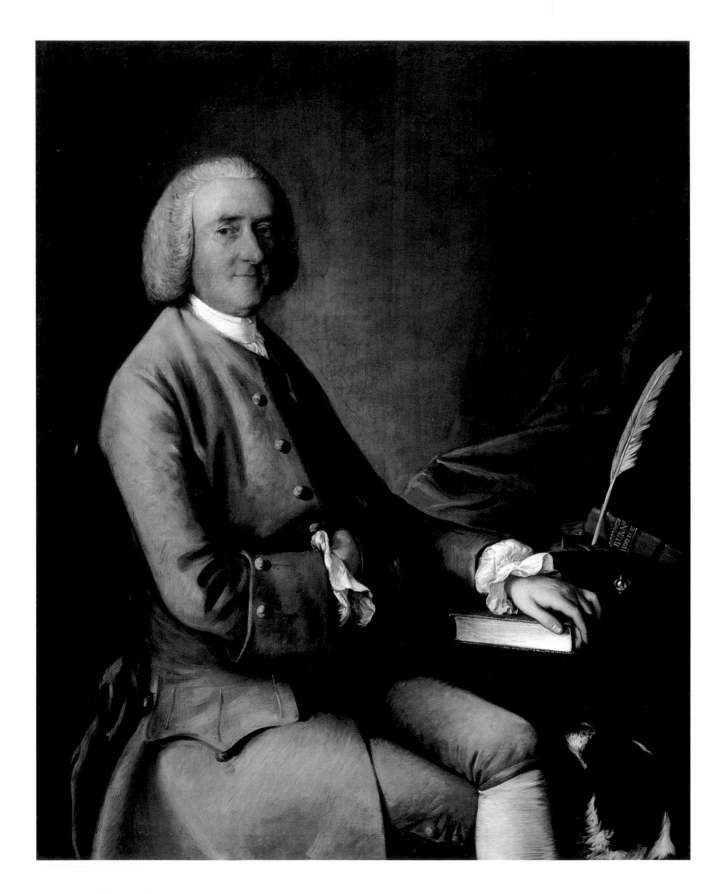

Henry Wise (fig. 49). Wise appears to have visited the city at the beginning and end of 1759; arrivals are recorded on 1 January and 24 December. His portrait has the similar qualities of directness and simplicity as those in the portrait of John Sparrowe. The colour is similar, as is the pose with the sitter's hand tucked into his waistcoat in the fashion of the time. We know that Gainsborough also painted Mr and Mrs William Lee of Hartwell House, Buckinghamshire, a pair of portraits for which he received sixteen guineas in April 1759.[38]

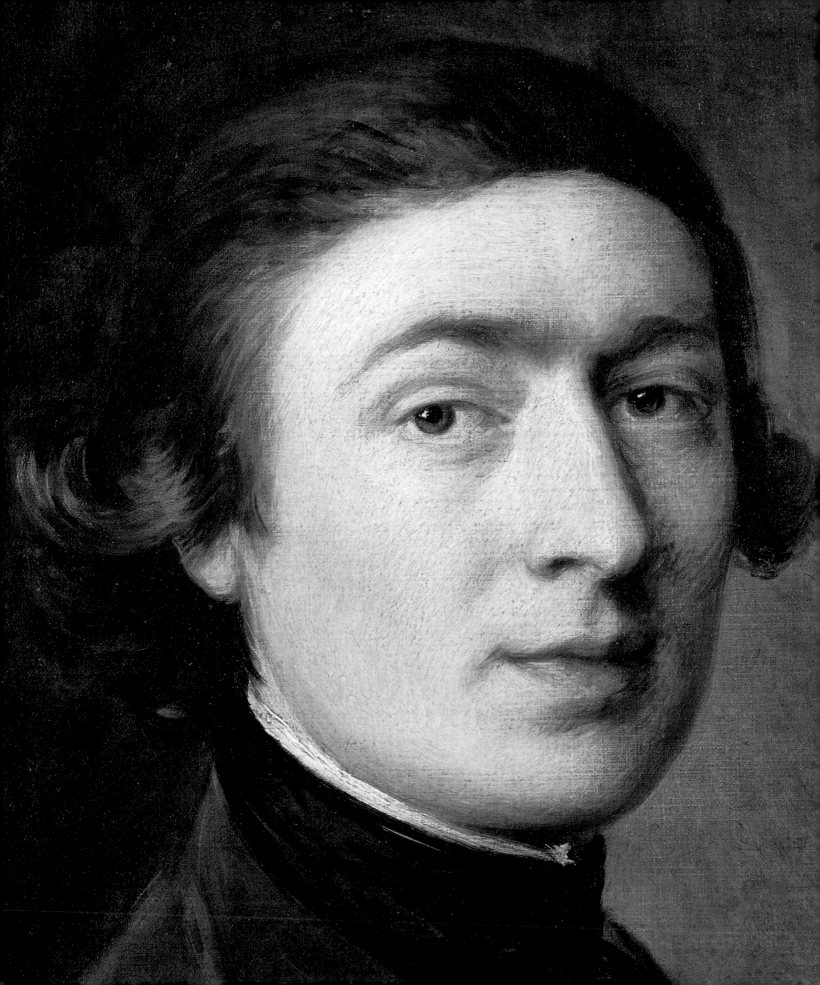

V A Provincial Master

Exactly when Gainsborough returned to Ipswich is unknown. He probably stayed in Bath until the end of the season in May returning to his beloved Suffolk countryside for a spate of painting before taking his family to the West Country. The landscape now in the Beaverbrook Art Gallery in Fredericton, Canada, is much more delicate than some of his earlier work and takes its inspiration from Italianate Dutch landscape painting (fig. 51). The delicate framing tree, inspired by the Dutchman Adam Pynacker, is more convincing than the framing devices seen in the portrait of *Bumper* and the landscape from Philadelphia (fig. 14); the hillock in the foreground, the playfulness of the animals and the pink light of sunset are closer to the work of Aelbert Cuyp and Nicholas Bercham than other landscapes. The estuary too, complete with sailing boats, has only occasionally appeared in earlier paintings. The composition has a feeling of much greater confidence and ease. Similar themes are seen in a landscape drawing of about the same date, one of which shows a bullock cart travelling beside a river estuary with a complex bank of scrub rising to the right (fig. 50).

Most unusual is a third landscape which was painted for Robert Edgar of Red Lodge, Ipswich who, with his three sisters, had all been painted by Gainsborough

Fig. 50
Thomas Gainsborough,
*Ox Cart by the Banks
of a Navigable River*,
c. 1758.

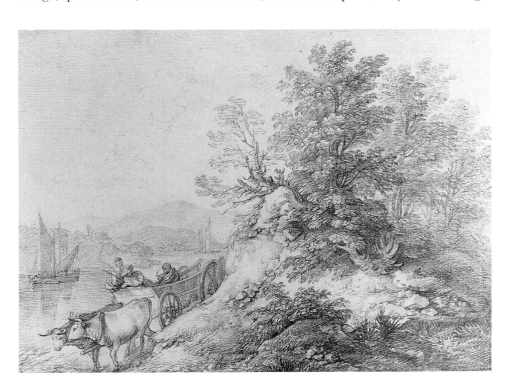

Detail of
Thomas Gainsborough,
Self-portrait, c. 1759.
(see fig. 60, p. 83)

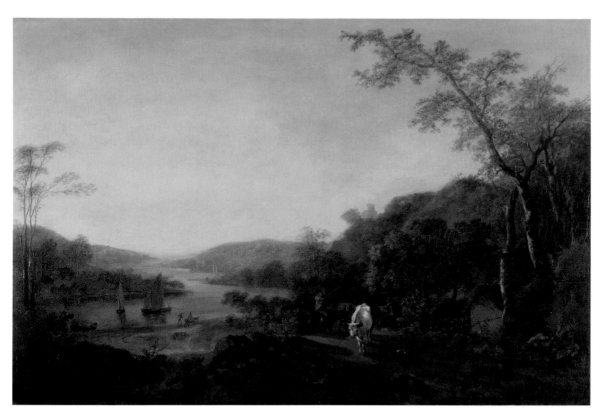

Fig. 51
Thomas Gainsborough,
*An Extensive River
Landscape with
Cattle and a Drover
and Sailing Boats
in the Distance,*
c. 1757–59.

in the 1750s (fig. 53). It is rare for Gainsborough to use an oval format and in this canvas, like the pair of landscapes painted for the Duke of Bedford, the figure takes on an increased importance. The young shepherd, stick in hand, watches over a small flock of sheep before a delicately painted landscape. Three drawings are related to the composition. One shows the boy with his flock and the other two are studies of sheep. This arrangement dissatisfied Gainsborough; perhaps the sheep placed parallel to the picture plane distracted attention away from the shepherd boy. Instead he chose a tighter and more complex group of sheep which, uniquely, are copied from a small painting on copper by Karel Dujardin dated 1673 which is now in the National Gallery in London (fig. 52). Unfortunately the eighteenth-century provenance of the Dutch painting is unrecorded, though it must have been a painting that was readily accessible to Gainsborough. Perhaps it belonged to him or even the Edgars.[39]

On 20 October 1759 the *Ipswich Journal* included an advertisement to sell 'All the Household Goods of Mr. Thomas Gainsborough, with some Pictures and original Drawings in the Landskip way by his own hand, which, as he is desirous of leaving them among his friends, will have the lowest prices set upon them'. Among the canvases for

Fig. 52
Karel Dujardin, *Sheep and Goats,* 1673.

Fig. 53
Thomas Gainsborough,
The Shepherd Boy, c. 1757–59.

sale was the portrait of the *Painter's Daughters chasing a Butterfly* (fig. 44) which was bought or given to the Reverend Robert Hingeston, the Master of Ipswich School, a close neighbour of Gainsborough. At about this time Gainsborough had painted other double portraits of his daughters. One of them showed the two daughters 'in the garb of peasant girls, on the confines of a corn-field, dividing their gleanings. They appear to be about eight or nine, and are of the size of life. The painting is pure, and the characters are natural, clothed with the utmost simplicity of art'.[40] Unfortunately the painting, never finished, was cut into two and only the left hand half, showing Margaret, is extant (fig. 54).

The young Margaret appears to be holding out her apron in readiness to collect her gleanings; the artist has clearly taken great pleasure in restricting the palette to the blue-greys of an East Anglian sky and the golden brown-yellows of the little girl's clothes. Although the portrait is painted with the empathy of the earlier double portrait, with a large bundle of corn painted over the figure, it is difficult to appreciate how the composition might have been resolved. Nonetheless the portrait is painted with the melancholy of lost youth and a fluency which has only occasionally appeared in Gainsborough's works. Similar qualities appear in the portrait of a young woman dressed in blue, a white silk shawl over her shoulders and a sprig of lily-of-the-valley in her corsage (fig. 55). Compared to the portrait of Mrs Rustat the sitter is more relaxed, the angle of the body and the turn of the head more natural and the costume less regimented. The visit to Bath had obviously had a major effect. Details such as the accidental fall of the choker ribbon, emphasising the sitter's neck, and the uneven tie knot of the shawl created further interest.

Another exceptional portrait which, like the *Daughters chasing a Butterfly*, appears to anticipate the extraordinary achievements of the artist later in his career, is the *Portrait of William Wollaston* (fig. 56). He was the Member of Parliament for Ipswich, though he may never have spoken in the House and had extensive estates in Leicestershire and at Great Finborough, about twelve miles west of Ipswich. The portraits shows Wollaston seated in a chair with a diamond-shaped seat, with his elbows on the arms, and holding a one-keyed boxwood flute. His attention has been caught by something on his left, and his left leg crosses his right so the whole figure becomes a spiral accented by the diagonals of the music sheet (of fictional notation), the edge of his waistcoat and the flute he holds across his chest. The silk lining of his wool coat provides a second spiral on the left and the red curtain, which gives a context for the sitter, provides a similar resonance. It is startling in its informality and its realism: the contrasting textures of wool, silk and velvet have never been rendered more convincingly. Although the sitter's musical interest is unrecorded, he must have been close to Gainsborough for the artist to have produced such a penetrating portrait. Compared to the overwrought portrait of Nassau (fig. 47), the starchy portrayal of Sparrowe (fig. 48), or, indeed, the uneasy full-length of Wollaston himself, this painting is among the best. It illustrates the natural ease that Gainsborough appears to have adopted once he got to Bath. The sitter is

Fig. 54 Thomas Gainsborough, *Margaret Gainsborough gleaning* (fragment), c. 1758.

Fig. 55
Thomas Gainsborough,
Portrait of a Young Woman,
c. 1759.

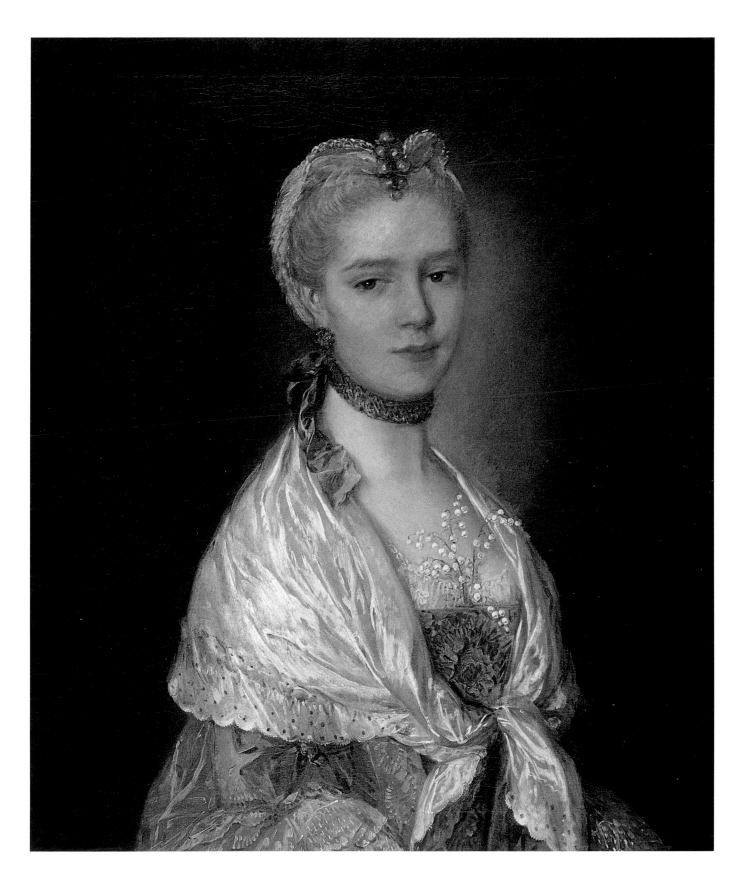

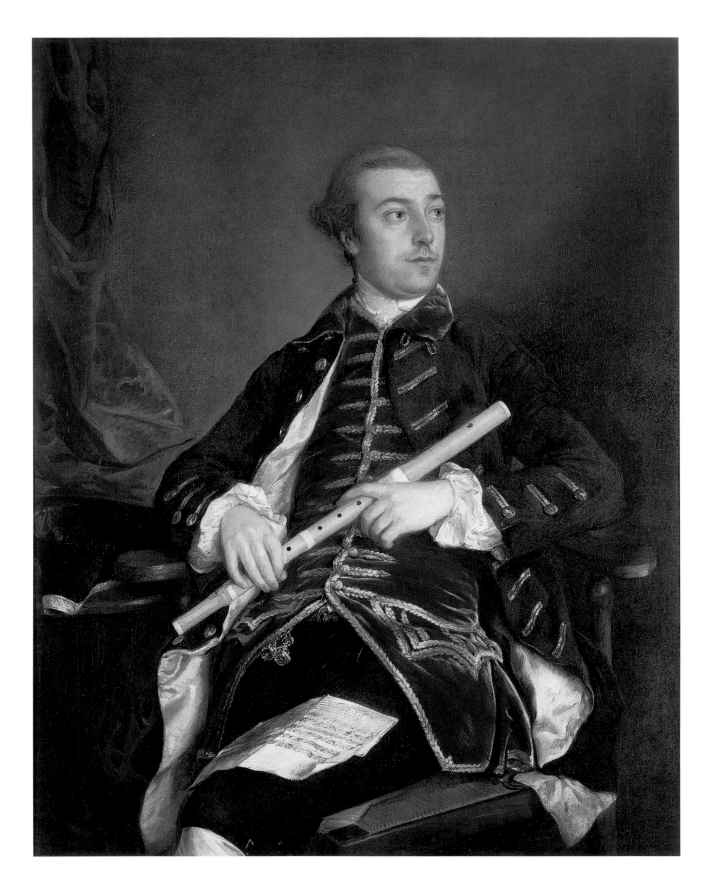

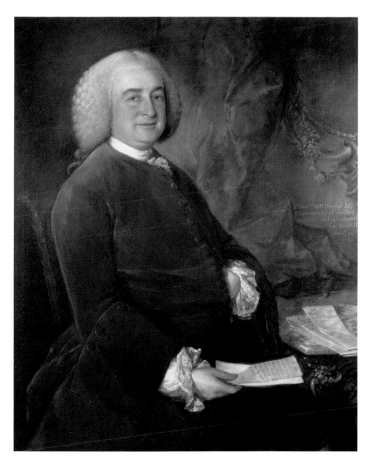

recorded in the city in 3 September 1759 and, despite the association with Suffolk, it is tempting to assume that the painting was among Gainsborough's first commissions in the West Country.

A more formal three-quarter length is the *Portrait of Robert Nugent*, commissioned early in 1760 to commemorate, as the inscription states, that he was 'unanimously re-elected member of Parliament for Bristol [on] Dec.r 26th.1759' (fig. 57). He is shown in a pose similar to that of John Sparrowe, seated in front of a console table with a pile of papers inscribed with the details of acts of parliament which he had implemented in previous sessions. As a public commission, seen by many, Nugent's portrait must have encouraged both Sir William St Quintin, a Yorkshire landowner and collector, and Thomas Coward to commission very similar canvases (the latter reversing the pose).[41]

Gainsborough's earliest contacts in Bath appear to have been Torys and among the most important, cousins of the Beauforts to whom his wife was connected, were the Price family of Foxley House in Herefordshire. He not only painted the elderly Uvedale Tomkins Price (fig. 58) but also two portraits of his son, Robert, shortly before the latter's premature death in 1761. There was much common ground: both artist and the younger Price, some of whose attributes were inherited from his father, showed interests in 'improving landscape', drawing and in making music. In the portrait of the elder Price, Gainsborough produced one of his most remarkable and haunting portraits. On the back wall is a framed drawing reminiscent in style to that of the *Ox Cart by the Banks of a Navigable River* (fig. 50). Beneath it are portfolios stuffed with other work; in the sitter's left hand is a half-finished landscape drawing and in his right a portacrayon. Remarkably, striving for realism, Gainsborough made the drawings with chalk drawn straight on to the ivory-coloured ground. The colours have been especially carefully balanced. The sitter wears a gold-edged waistcoat, which picks up the colour of the frame on the drawing, and a chestnut-brown coat made warmer by his crimson damask-covered chair which, presumably for pictorial rather than logical reasons, is higher on the sitter's right-hand side than the left. It is a bold composition, comparable to the portrait of Wollaston, and uses the strong diagonal of the sitter's right arm to contrast with the rectilinear forms of the chair back and picture frame. The Foxley estate was hugely influential to the young Gainsborough and provided opportunities for him to see drawings by Giovanni Battista Busiri, which are echoed in watercolour drawings and gouaches he produced in the early 1760s. He used the famous group portrait of the Price family by Bartholomew Dandridge for the composition of his huge double portrait of Mr and Mrs George Byam and at least one

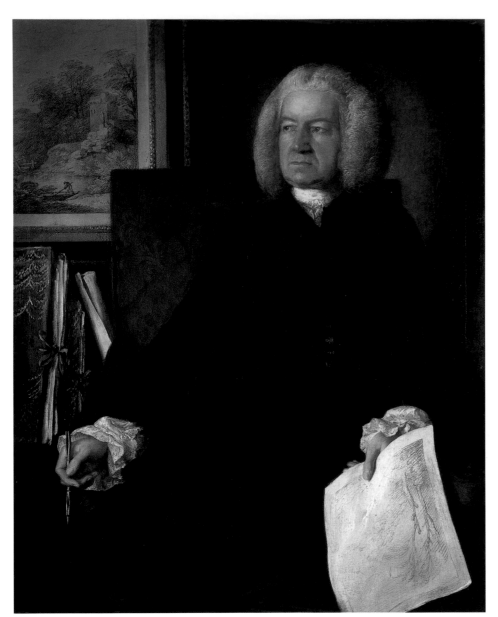

Fig. 60
Thomas Gainsborough,
Self-portrait,
c. 1759.

Fig. 59
John Wood the Elder (1704–54) (attr.),
Elevation and ground plan of Kingston House,
Abbey Street, c. 1745.

landscape painting by Gaspard Dughet is recorded in a print by Gainsborough's associate Joseph Wood (cf. fig. 21).

It is not known where Gainsborough lived with his family when they first moved to Bath. On 24 June 1760, however, Gainsborough signed a renewable seven-year lease for a large house owned by the Duke of Kingston's estate (fig. 59). It was situated in the centre of the city overhanging a pathway to the Roman baths and facing the west end of the Abbey. Gainsborough could not have made a more affirmative statement of his self-confidence and ambition. To help fund the rent Gainsborough took in paying guests, converted the room on the left of the entrance as a 'Shew' room and eventually invited his widowed sister, Mary Gibbon, to open her millinery shop in the room at the other side of the

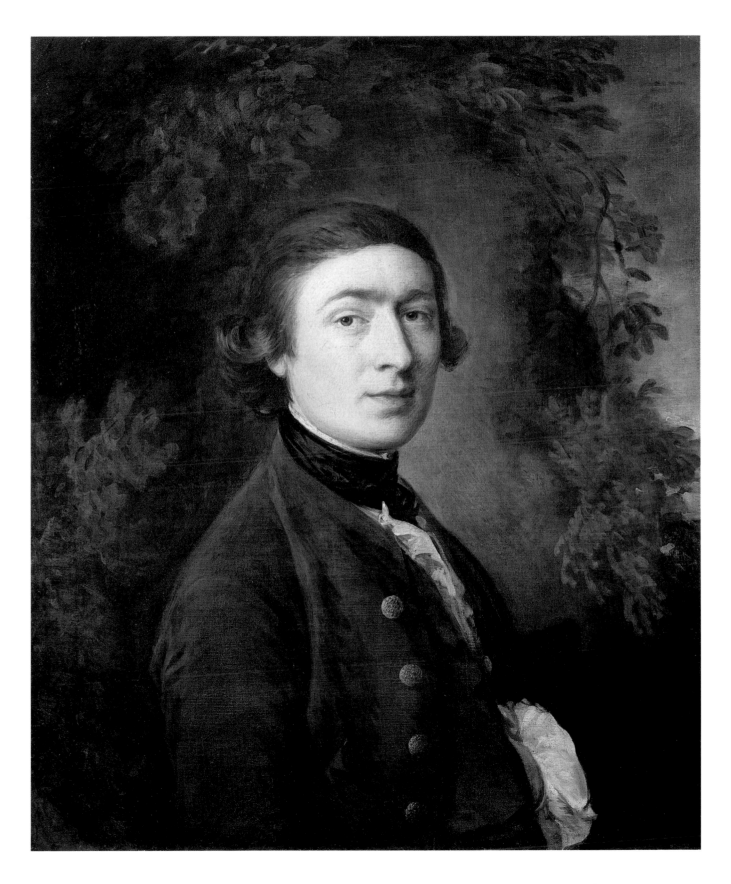

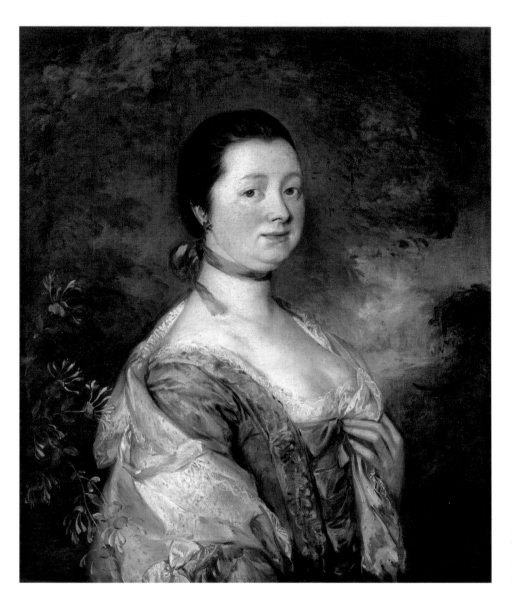

Fig. 61
Thomas Gainsborough,
Portrait of Mrs Margaret Gainsborough,
c. 1759.

entrance. The *Self-portrait* (fig. 60) and the *Portrait of Mrs Margaret Gains-borough* (fig. 61), who, echoing the Devis portrait (fig. 29), is shown beside a honeysuckle plant to show her close connection and dependence on her husband, were painted to mark their new beginning and it is tempting to assume that at least the portrait of the artist would have welcomed visitors to the new 'Shew' Room. It is worth comparing this self-portrait with the earlier unfinished self-portrait of 1754 (fig. 39) in which the artist lacks assurance and drive. In the later work there is a definite sense of purpose.

In one of the letters written by the inveterate correspondent, Mary Delany, she records a visit to the studio. She does not mention seeing the portraits of Gainsborough and his wife, but commented on the *Portrait of Ann Ford* (fig. 62) thus: 'There I saw Miss Ford's picture, a whole length with her guitar, a most extraordinary figure, handsome and bold; but I should be very sorry to have any

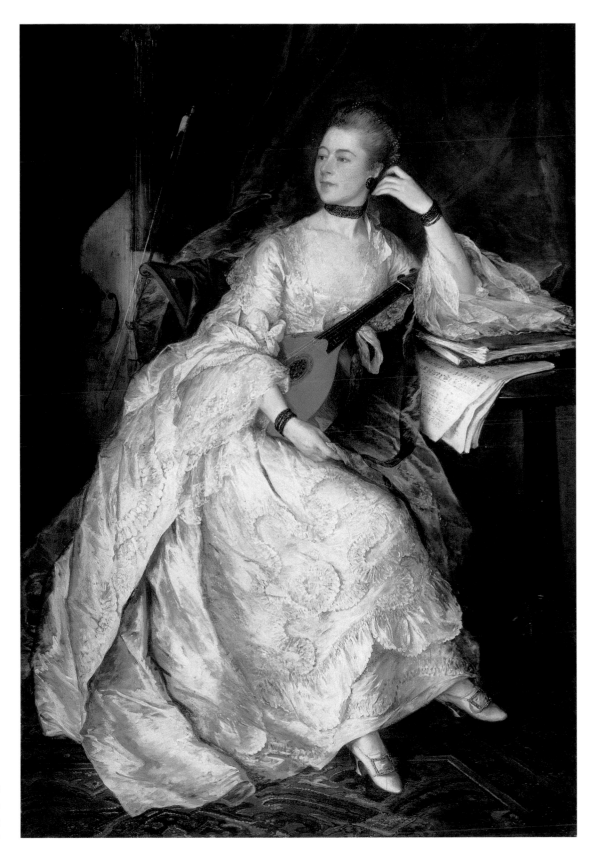

Fig. 62
Thomas Gainsborough,
Portrait of Ann Ford,
1760.

one I loved set forth in such a manner'. The cast of Miss Ford's head is less than demure and Mr Wetenhall Wilkes, the author of a manual which attempted to give advice to those seeking to have acceptable manners, suggests that ladies should not cross their legs above the knee, 'for such a free posture unveils more of a masculine disposition than sits decent upon a modest female'. Her behaviour had been, as one observer noted, 'Mad with Vanity and Pride'. She gave public performances on the viol da gamba, which, judging from Gainsborough's portrait of the Reverend John Chafy (now in Tate Britain) painted eight years earlier or the near-contemporary portrait of his friend Carl Friedrich Abel (in the National Portrait Gallery, London), demanded a similarly unfeminine contortion of the legs. Indeed a public performance on the most feminine of instruments, the English guitar, was regarded as an

Fig. 63 William Hogarth,
The Lady's Last Stake, 1759.

invasion of the male preserve, and this is indicated in the manner in which she holds the instrument in her lap as a symbol of male virility. Her behaviour was so wide of the mark that twice she was arrested on the instruction of her father for performing music in public. The amorous intentions of Lord Jersey and the offer of £800 to become his mistress, which was publicised in a series of squibs, provided further reason for notoriety. The charismatic Miss Ford was a figure whom everyone knew in Bath, and she was the perfect choice for Gainsborough to make the centrepiece in his new 'Shew' Room. In a contrary way, the sitter's disregard for public propriety provided the means by which Gainsborough was able to advertise his abilities to the public.[42]

Reference is made to Miss Ford's recent history in the similarity of pose between Gainsborough's portrait and that of the young woman in *The Lady's Last Stake* by the artist's great mentor William Hogarth (fig. 63). In the Hogarth, the woman had lost at cards and the young blade with whom she had been playing has made the ungallant suggestion of how she could regain her losses, a proposal which, given the handsome demeanour of her companion, the young woman is considering in too coquettish a manner. The canvas would have been known by the art-loving public as it had been exhibited in Hogarth's studio in London before being shown at the Society of Artists' exhibition in 1761. Gainsborough synthesises Hogarth's pose and accentuates the spiral composition noted in the portrait of Wollaston. Two studies for Gainsborough's portrait are recorded and go some way to indicate the importance the artist invested in it. It shows the artist's expertise in delineating the serpentine ruched decoration on the skirt, the sheets of music which are only half on the table and the dramatic diagonals of the crimson curtain foiled by the line of the pose. The portrait has the same

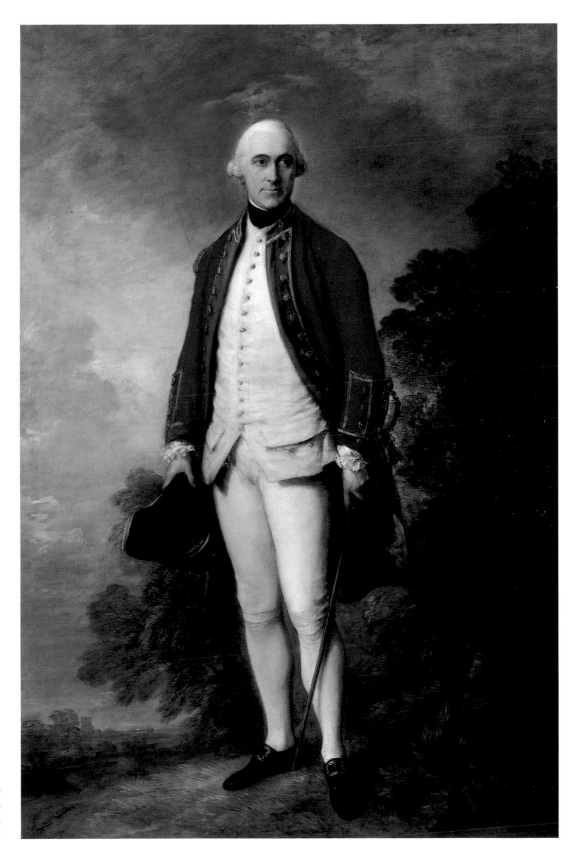

Fig. 64
Thomas Gainsborough,
George Pitt, First Lord Rivers,
1769.

intense energy as the Muilman conversation piece (fig. 16) but it needs some assimilation into the artist's personal style. Given Gainsborough's own interest a musical analogy is perhaps not inappropriate. Ann Ford's portrait has the rawness and splendour of trumpets: once Gainsborough's visual memory has digested the graceless pose, the abstract arrangement of viol da gamba, curtain and skirt, his work will, to use his own words, be more tuneful: 'One part of a Picture ought to be like the first part of a Tune, that you can guess what follows, and that makes the second part of the Tune'.[43]

Apart from providing a ready market for portraits, Bath also provided riches that Gainsborough had only glimpsed in London twelve years earlier. There were print shops, contact with collectors as well as proximity to collections. Consequently Gainsborough could study paintings, either directly or through prints, round about the city or in conveniently placed country houses situated between Bath and London. He was especially enamoured with the work of Sir Anthony van Dyck and Sir Peter Paul Rubens, and his admiration is recorded in a number of copies and a few purchases for his own collection. By the time of the first exhibition at the Royal Academy, when he exhibited the portraits of Lady Molyneux (fig. 65) and George Pitt (fig. 64), he was not only able to produce unequalled likenesses but, having learnt lessons from his seventeenth-century mentors, Gainsborough was able to give his sitters an ease and distinction that combined approachability with grandeur.[44] Nonetheless the canvases from around 1770 reveal an approach which can be traced back to his very earliest work. The handling of the paint, the 'odd scratches and marks' as Sir Joshua Reynolds referred to them, was the result of expediency as well as ability. After all he had no studio assistance until the arrival of his nephew, Gainsborough Dupont, in 1772, and he was in competition with those that did. His extraordinary visual memory, honed by countless drawings of rural Suffolk, enabled him to unite hand and vision with lightning speed that brought an immediacy to his work and seemed original in comparison with the stolid technique of his contemporaries who relied so heavily on inspiration from Old Masters and the antique. There were aspects of his character which found portrait painting difficult, but his special gifts and use of pyrotechnics, developed for sound reasons, enabled him to play to the gallery. His public would have adored the use of darkened rooms, his graphic wizardry and his wit which made him a success as a portraitist. As a landscape painter performance was unnecessary and these tensions were made much easier.

For an artist with so much natural talent, it seems extraordinary that Gainsborough took so long to find his own voice. A difficult family life, frustrated by a healthy income from his wife who regarded her painter husband as little more than an artisan, must have stalled his development and, while the best of his work in Suffolk — The Charterhouse (fig. 25), Mr and Mrs Andrews (fig. 28) and the Daughters chasing a Butterfly (fig. 44) — are amongst the best-loved images from the eighteenth-century, they come from a turbulent period which provided the foundations for the extraordinary achievements of his later career.

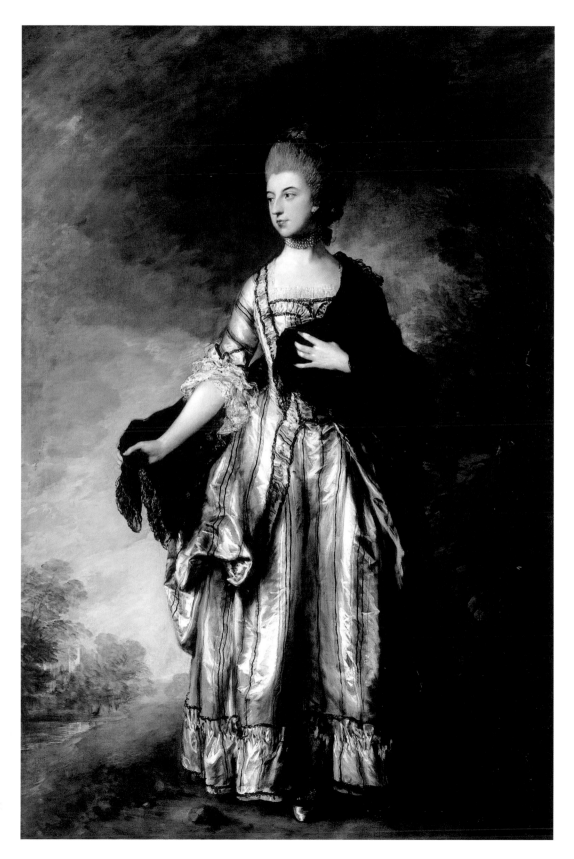

Fig. 65
Thomas Gainsborough,
Isabella, Viscountess Molyneux
(later Countess of Sefton),
1769.

Notes and References

1 Quoted by J. Hayes in his Tate Gallery exhibition catalogue, *Gainsborough*, 1981, p. 13.

2 *Sir Joshua Reynolds Discourses on Art*, edited by R. R. Wark, New Haven and London, 1959, p. 250.

3 Daniel Defoe, *Tour Through the Eastern Counties*, (ed. R. A. N. Dixon), Ipswich, 1949, p. 64. The first edition was published in 1724.

4 According to the provenance the door panels came from a house in Gainsborough's possession. They are now in an English private collection (J. Hayes, *The Landscapes of Thomas Gainsborough*, London and Ithaca 1982, p. 31 repr.). The so-called self-portrait was first published by Corri (*Burlington Magazine*, CXXV, April 1983, frontispiece) and has been more readily accept by other authorities.

5 Reverend Sir Henry Bate-Dudley in *Morning Herald*, 8 August 1788.

6 This suggestion comes from a manuscript note in Colonel Cunningham-Lane's annotated copy of A. Cunningham, *The Lives of the Most Eminent British Painters, Sculptors & Architects*, London 1829 in the National Art Library, Victoria and Albert Museum. A suggested identity of the silversmith, which has been generally rejected, was made by E. Barr, 'Gainsborough and the Silversmith', *Burlington Magazine*, CXIX, February 1977, p. 113.

7 Both quotes are included in I. Bignamini, 'George Virtue, Art Historian and Art Institutions in London 1689–1768: A Study of Clubs and Academies', in *Walpole Society*, LIV, 1988, pp. 99–100.

8 Recorded by William Blake, *Public Address* and quoted by H. Hammelmann, *Book Illustrators in Eighteenth Century England*, New Haven and London 1975, p. 39.

9 Anonymous reviewer of G. W. Fulcher *Life of Gainsborough in Gentleman's Magazine*, August 1856, p. 199.

10 B. Allen, *Francis Hayman*, New Haven and London 1987, p. 92.

11 [John] Oldfield sale, Prestage's, 7–8 February 1766, lots 17 and 56 (Lugt, 1497) E. K. Waterhouse, *Gainsborough*, London 1958, p. 13 and A. Corri, 'Gainsborough's early career: new documents and two portraits', *Burlington Magazine*, CXXV, April 1983, p. 213.

12 Letter to Thomas Harvey dated 22 May 1788 (J. Hayes, *The Letters of Thomas Gainsborough*, New Haven and London 2001, no. 108, p. 174; hereafter Hayes 2001).

13 John Hayes, 'British Patrons and Landscape Painting: 1. Eighteenth-century collecting', *Apollo*, CLXI, March 1966, pp. 188–97, especially page 190.

14 *Morning Herald*, 8 August 1788

15 Letter to James Unwin dated 25 October 1763 (Hayes 2001, p. 23).

16 Dated Pall Mall, 11 March 1788 (Hayes 2001, no. 104, pp. 168–89).

17 Letter to William Jackson dated 23 August [1767] (Hayes 2001 no. 22, p. 40).

18 See Ann Bermingham, *Landscape and Ideology: The English Rustic Tradition, 1740–1860*, London 1987, pp. 39, 204, note 67.

19 Rica Jones, 'Gainsborough's materials and methods: a 'remarkable ability to make paint sparkle', *Apollo*, CXLVI, August 1997, pp. 20–21.

20 G. W. Fulcher, *The Life of Gainsborough*, London 1856, p. 206.

21 A. Cooper, *Our Mother Earth*, privately printed, 1998, pp. vii–ix.

22 Both quotes come from the particulars of the sale of the estate by Christie's on 25 September 1806.

23 D. Defoe, *Tour through the Eastern Counties*, op. cit., p. 64.

24 P. Thicknesse, *A Sketch of the Life of Gainsborough*, London 1788, pp. 12–15

25 Quoted by R. Sedgwick, *History of Parliament: The Commons 1715–54*, [2 vols] London 1970, pp. 497–98.

26 J. Hayes and L. Stainton, *Gainsborough's Drawings*, catalogue of an exhibition organised by the International Exhibitions Foundation, Washington D.C., 1983, p. 1.

27 H. Belsey, 'Thomas Gainsborough as an Ipswich Musician, a Collector of Prints and a Caricaturist' *East Anglia's History*. Edited by Christopher Harper-Bill et al, Woodbridge 2002, pp. 289–301.

28 The print was republished in 1764 after Major's death. See H. Belsey, *Gainsborough at Gainsborough's House*, exhibition catalogue, London 2002, nos. 33 and 34.

29 M. Rosenthal, *British Landscape Painting*, London 1982, p. 32.

30 J. Hayes, *The Landscape Paintings by Thomas Gainsborough*, 1982, pp. 393–95 repr. and H. Belsey and C. Wright, *Gainsborough Pop*, forthcoming.

31 E. K. Waterhouse, *Gainsborough*, London 1958, no. 765, pl. 26.

32 E. K. Waterhouse, *Gainsborough*, London 1958, no. 40, pl. 32.

33 Hayes, 2001, p. 90.

34 Hayes, 2001, pp. 10–11.

35 See J. Hayes, 'Some Unknown Early Gainsborough Portraits', *Burlington Magazine*, CVII, February 1965, pp. 69–73.

36 Noted by J. Hayes, 'Some Unknown Earlier Gainsborough Portraits', *Burlington Magazine*, CVII, February 1965, pp. 70, 72.

37 Quoted by S. Sloman, 'Gainsborough in Bath 1758–9', *Burlington Magazine*, CXXXVII, August 1995, p. 510.

38 S. L. Sloman, 'Gainsborough in Bath 1758–59', *Burlington Magazine*, CXXXVII, August 1995, p. 511.

39 All the drawings and paintings are illustrated by Hayes in *Thomas Gainsborough*, exhibition catalogue, Palazzo di Diamanti, Ferrara, 1998, no. 36.

40 W. H. Pyne, *Somerset House Gazette*, 7 August 1824, p. 272.

41 E. K. Waterhouse, *Gainsborough*, London 1958, no. 595, pl. 59 and no. 169, pl. 58 respectively.

42 The quotations and ideas in this paragraph are expanded in M. Rosenthal, 'Thomas Gainsborough's "Ann Ford"', *Art Bulletin*, LXXX, December 1998, pp. 649–56.

43 From a letter dated about 1770 to William Jackson cited in Hayes 2001, p. 71.

44 E. K. Waterhouse, 'Bath and Gainsborough', *Apollo*, XCVIII, November 1973, p. 365.

Further Reading

The list below is an up-to-date list of books and articles about all aspects of Gainsborough's life and work. It is not a comprehensive list; many important articles are mentioned in these works' bibliographies and in the present footnotes. The reader is directed towards John Hayes, *The Drawings of Thomas Gainsborough*, (2 vols.), London, 1970 and John Hayes, *The Landscape Paintings of Thomas Gainsborough*, (2 vols.), London, 1982 for more comprehensive listings. Much new research is listed in *Gainsborough's House Review* which is published each September.

W. T. Whitley, *Thomas Gainsborough*, London, 1915. This remains the most thorough biography of the artist.

E. K. Waterhouse, *Gainsborough*, London, 1958 (2nd edn. 1966). Although the landscape paintings have been re-catalogued, this book remains the most important catalogue of the artist's portraits.

John Hayes, *The Drawings of Thomas Gainsborough*, (2 vols.), London, 1970. A well illustrated catalogue of Gainsborough's drawings. An addenda was published by John Hayes as 'Gainsborough's Drawings: A Supplement to the Catalogue Raisonée', in *Master Drawings*, XXI no 4, 1983, pp. 367–91.

John Hayes, *Gainsborough as Printmaker*, London, 1971. A fully illustrated catalogue of Gainsborough's work as an etcher and aquatinter.

John Hayes, *Gainsborough*, London, 1975. A fully illustrated book about the artist with an essay placing him in context.

John Hayes, *Thomas Gainsborough*, catalogue of an exhibition at the Tate Gallery, London 1980/81. A fully illustrated catalogue with a lively biography of the artist.

John Hayes, *The Landscape Paintings of Thomas Gainsborough*, (2 vols.), London, 1982. A full catalogue which traces the development of Gainsborough's landscape style and places it in context.

Hugh Belsey, *Gainsborough's Family*, catalogue of an exhibition of Gainsborough's House, Sudbury, 1988. A study of the artist's family including family trees.

Malcolm Cormack, *The Paintings of Thomas Gainsborough*, Cambridge, 1991. An introductory essay about the artist's work with 75 colour plates illustrating the scope of his paintings and drawings.

John Bensusan-Butt, *Gainsborough in his Twenties*, privately printed, 1993. An accumulation of local sources and biographical information about Suffolk sitters.

Judy Egerton, *National Gallery Catalogues: The British School*, New Haven and London, 1998. Analytical catalogue of the National Gallery's collection which includes *Mr and Mrs Andrews*, *The Painter's Daughters chasing a Butterfly* and *Cornard Wood*.

Michael Rosenthal, *The Art of Thomas Gainsborough*, New Haven and London, 1999. A study which places Gainsborough in the context of the Royal Academy and pays particular attention to the influences that formed his style.

Amal Asfour and Paul Williamson, *Gainsborough's Vision*, Liverpool University Press, 1999. Much new information emphasising the influence of the artist's non-conformist upbringing and suggesting new sources for his work.

Robin Asleson and Shelley Bennett, *British Paintings at the Huntington*, New Haven and London, 2001. Catalogue of the collection in San Marino, California, which mainly includes later portraits from the artist's career.

John Hayes (ed.), *The Letters of Thomas Gainsborough*, New Haven and London, 2001. A new edition of all Gainsborough's known letters and other writings.

Hugh Belsey, *Gainsborough at Gainsborough's House*, London, 2002. A catalogue of the collection in Sudbury, rich in drawings from throughout the artist's career.

Michael Rosenthal and Martin Myrone (eds.), *Gainsborough*, London, 2002. The catalogue of an international exhibition which concentrates on Gainsborough's exhibited works and the influences that shaped his work.

Susan Sloman, *Gainsborough in Bath*, New Haven and London, 2002. Places Gainsborough in the context of the artistic life of the city with much new information about his patronage and development.

Gainsborough's House Review
An annual booklet which outlines the activities of the Society, lists new acquisitions and publishes recent research about the artist and his associates.

Chronology

1727 14 May. Gainsborough was baptised at the Independent Meeting House in Friar's Street, Sudbury, the son of John Gainsborough and his wife Mary Burrough. He was the youngest of nine children.

1739 16 March. His uncle, Thomas Gainsborough, was buried. He bequeathed £10 towards the artist's apprenticeship together with £10 more 'if he shall prove sober and likely to make good use of it'.

c. 1740 He travelled to London and subscribed to the St Martin's Lane Academy where he was taught by the French draughtsman and engraver, Hubert-François Gravelot.

1742/3 He assisted Francis Hayman with the painting of the supper-box paintings to decorate the Grove in Vauxhall Gardens. He may also have lived with Hayman.

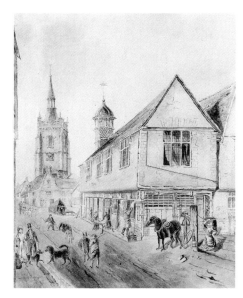

James Scales (attr.), *View of Market Hill, Sudbury, from the west*, c. 1830. Watercolour over pencil, 40.8 x 31.2 cm. Gainsborough's House, Sudbury.

c. 1743 Lodged with John Jorden in Little Kirby Street, Hatton Garden.

1745 His first dated painting of *Bumper*, '*a most sagacious curr*'.

1746 15 July. He was married at Dr Keith's Mayfair Chapel in London. His wife was Margaret Burr, an illegitimate daughter of Henry, 3rd Duke of Beaufort who settled an annuity of £200 on her. Her mother was probably Scottish. Mrs Gainsborough may have been pregnant at the time of their marriage. They moved to 67 Hatton Garden.

1747 His first dated landscape painting (*Rest on the Way*, now in Philadelphia Museum of Art).

1748 1 March. 'Mary Gainsborough of Hatton Garden' was buried at St Andrew's, Holborn.
 Documentary sources state *Cornard Wood* was completed during the year.
 29 October. His father, John Gainsborough, died and was buried at St Gregory's, Sudbury.
 November. The artist presented *The Charterhouse* to the Foundling Hospital.

1749 Early in the year the artist and his wife moved to Sudbury, probably renting a house in Friar's Street from his cousin, Mary.

1750 3 February. His elder daughter, Mary, was baptised at All Saints', Sudbury.

1751 22 August. His younger daughter, Margaret, was baptised at St Gregory's, Sudbury.
 Moved to Ipswich either late in 1751 or early in 1752, initially living in a house in Brooke Street.

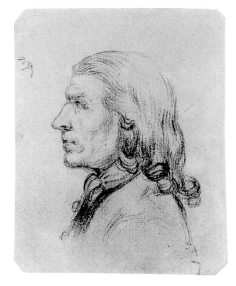

Thomas Gainsborough, *John Gainsborough*, 1751. Pencil, 9.4 x 7.4 cm. Gainsborough's House, Sudbury.

1752 By June he was renting a house in Foundation Street near the Shire Hall from an Ipswich grocer, Thomas Raffe.

1753 Met Philip Thicknesse who commissioned an overmantel of Landguard Fort.

1755 Completed two overmantels commissioned by John, 4th Duke of Bedford for Woburn Abbey.

1758 October. He visited Bath and painted portraits of *Mr and Mrs Lee*, *Lord Jersey* and *Henry Wise*.

1759 May. Returned to Ipswich at the end of the Bath season.
 22 and 23 October. Sold his household goods and the contents of his studio in Ipswich.

1760 24 June. He signed a seven-year lease for a large house in Abbey Street, Bath,

from the Duke of Kingston's estate, where he took in lodgers.

23 October. In a letter to Mrs D'Ewes, Mrs Delany reported visiting Gainsborough's studio and seeing the *Portrait of Ann Ford*.

1761　May. He exhibited his *Portrait of Lord Nugent* at the Society of Artists' exhibition.

1763　May. He exhibited a *'Grand Landscape'* at the Society of Artists' exhibition, generally identified as the landscape in Worcester Museum of Art.

August/September. Suffered from 'a Nervous Fever', or a venereal disease, which debilitated him for at least five weeks.

October. Gainsborough's death is reported erroneously in the *Bath Journal*.

November/December. Moved to a house outside the city in Lansdown Road.

1766　Moved to a house in the Circus but continued to sublet the Abbey Street house.

1768　December. He was invited to become a founder member of the Royal Academy.

1769　May. Exhibited his portraits of *Lady Molyneux* and *Mr Pitt* at the Academy's first exhibition.

1772　12 January. Took his nephew, Gainsborough Dupont, as an apprentice.

May. He declined to exhibit at the Royal Academy exhibition and only submitted work again in 1777.

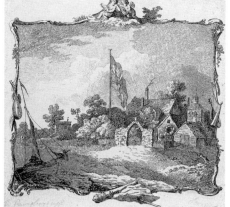

Thomas Gainsborough, *Perspective View of a Cottage near Landguard Fort in Suffolk*, c. 1754. Etching.

1774　June. Left Bath and took a lease on the western third of Schomberg House in Pall Mall where he built a studio and exhibition room in the garden.

1775　November. Visited in London by his widowed brother, Humphrey, who died a year later.

1777　May. After the intercession of Nathaniel Dance, he started to exhibit again at the Royal Academy where he showed the pendant portraits of the *Duke and Duchess of Cumberland*, his first paintings of Royalty, *The Hon. Mrs Graham* and *The Watering Place* all of which were lauded in the press.

September. Possibly joined his family who were visiting Samuel Kilderbee in Ipswich.

1779　July. Revisited Bath.

1780　21 February. His daughter, Mary, married the oboist, Johann Christian Fischer, but they soon parted.

1781　May. He exhibited full-length portraits of *George III* and *Queen Charlotte* at the Royal Academy exhibition. He exhibited and had engraved his first 'Fancy' picture, *A Shepherd*.

c. 1782　Sometime in the early 1780s he visited the West Country with Gainsborough Dupont, in particular Glastonbury and Tintern. At some point he also toured North Wales.

1782　September. He visited Windsor to paint ovals of the Royal family, a group of portraits he exhibited at the Royal Academy the following May.

1783　May. Submitted his exhibits for the Royal Academy late and complained about the hanging the group of oval portraits of the Royal Family 'above the line'.

Summer. Travelled with his friend Samuel Kilderbee to the Lake District.

October. He visited Antwerp where he judged the Gothic architecture to be 'like a cake *all plumbs*'.

1784　May. Submitted the portrait of the *Elder Princesses* to the Academy but withdrew it, with his other exhibits, as it was hung 'above the line'.

July. Opened his own exhibition at Schomberg House, an event which was repeated annually.

1786　January. Spent in Bath.

1788　April. Attended Warren Hastings's trial at Westminster Hall where he caught a chill.

2 August. Dies of 'a cancer of the neck' and is buried beside Joshua Kirby in St Anne's churchyard at Kew.

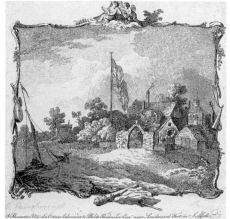

View of St. Andrew's Church Holborn

St Andrew's Church, Holborn, 1769. Engraving. From Chamberlain's *History of London*.

List of Illustrations and Picture Credits

Fig. 1:
Thomas Gainsborough, *Self-portrait*, c. 1754.
Pencil, on two pieces of paper, the figure
cut out and laid down on the landscape
background, 35.2 x 25.7 cm.
© Copyright The British Museum.

Fig. 2:
Gainsborough's House, street façade.
Gainsborough's House, Sudbury, Suffolk.

Fig. 3:
Hubert-François Gravelot,
Study of a Woman, c. 1744. Black-and-white
chalks on buff paper, 37.7 x 24.7 cm.
Ashmolean Museum, Oxford.

Fig. 4:
Johann Sebastian Muller (1715–c. 1785)
after Samuel Wale (?1721–86),
A General View of Vauxhall Gardens, c. 1751.
Engraving, plate size 29 x 40.5 cm.
Gainsborough's House, Sudbury, Suffolk.

Fig. 5:
Francis Hayman with
Thomas Gainsborough's assistance,
Children Building Houses with Cards, c. 1743.
Oil on canvas, 139.7 x 203.2 cm.
Private collection, England.

Fig. 6:
Thomas Gainsborough, *Portrait of a Girl
and Boy* (fragmentary) c. 1745.
Both oil on canvas, girl: 133.3 x 72.4 cm;
boy: 44.8 x 33.5 cm. Gainsborough's House,
Sudbury, Suffolk.

Fig. 7:
Thomas Gainsborough, *'Bumper', a Bull
Terrier*, 1745. Oil on canvas, 34.9 x 29.8 cm.
Private collection/Bridgeman Art Library.
Photo: John Webb.

Fig. 8:
Thomas Gainsborough, *Man in a Wood with
a Dog*, c. 1746. Oil on canvas, 66 x 49.5 cm.
Private collection on loan to Gainsborough's
House, Sudbury, Suffolk.

Fig. 9:
Francis Hayman and Thomas Gainsborough,
Portrait of Elizabeth and Charles Bedford,
c. 1746. Oil on canvas, 76.2 x 63.5 cm.
Private collection.

Fig. 10:
Thomas Gainsborough, *Conversation in
a Park*, c. 1746. Pencil, 20.2 x 26.8 cm.
Musée du Louvre, Paris. © Photo RMN.

Fig. 11:
Thomas Gainsborough, *Drinkstone Park*,
c. 1746. Oil on canvas, 145 x 144 cm.
Museu de Arte de São Paulo Assis
Chateaubriand, São Paulo, Brasil.
Photo: Luiz Hossaka.

Fig. 12:
Thomas Gainsborough, *Wooded Landscape
with River, Cattle and Figures after
Jacob van Ruisdael*, mid 1740s.
Chalk on paper, 40.8 x 42.2 cm.
The Whitworth Art Gallery, University
of Manchester.

Fig. 13:
Thomas Gainsborough, *Landscape
with a Peasant on a Path*, c. 1746–47.
Oil on canvas, 22.2 x 17.1 cm.
© Tate, London, 2002, on loan to
Gainsborough's House, Sudbury, Suffolk.

Fig. 14:
Thomas Gainsborough, *Rest on the Way*,
1747. Oil on canvas, 101.9 x 147.3 cm.
Philadelphia Museum of Art.

Fig. 15:
Thomas Gainsborough, *Self-portrait
with Wife and Daughter*, c. 1748.
Oil on canvas, 92.1 x 70.5 cm.
© National Gallery, London.

Fig. 16:
Thomas Gainsborough,
*Peter Darnell Muilman, Charles Crokatt
and William Keable in a Landscape*, c. 1748.
Oil on canvas, 76.5 x 64.2 cm.
© Tate, London, 2002 and
Gainsborough's House, Sudbury, Suffolk.

Fig. 17:
Thomas Gainsborough,
*Study for a Foreground, a Bank
with Weeds and Thistles*, c. 1750.
Pencil on paper, 13.7 x 15.5cm.
© Copyright The British Museum.

Fig. 18:
Francis Hayman (1708–76), *Jonathan
Tyers with his daughter and son-in-law,
Elizabeth and John Wood*, c. 1750.
Oil on canvas, 99.1 x 86.4 cm.
Yale Center for British Art, Paul Mellon
Collection.

Fig. 19:
Thomas Gainsborough, *Cornard Wood*, 1748.
Oil on canvas, 121.9 x 154.9 cm.
© National Gallery, London.

Fig. 20:
Map of Sudbury and Long Melford area.

Fig. 21:
Joseph Wood (d. 1763)
after Joshua Kirby (1716–74),
Lavenham Church from the South, 1748.
Engraving, trimmed, 24.8 x 31.1 cm.
Gainsborough's House, Sudbury, Suffolk.

Fig. 22:
William Hogarth, *The Idle 'Prentice at Play in the Church Yard during Divine Service*, plate 3 from *Industry and Idleness*, 1747. Engraving, plate size 26.7 x 34.7.

Fig. 23:
Thomas Gainsborough, *St Mary's Church, Hadleigh, Suffolk*, 1747–48. Oil on canvas, 91.4 x 190.5 cm. Private collection, England.

Fig. 24:
Court Room of the Foundling Hospital. Coram Foundation, Foundling Museum, London, UK/Bridgeman Art Library.

Fig. 25:
Thomas Gainsborough, *The Charterhouse, London*, November 1748. Oil on canvas, diam. 56 cm. Coram Foundation, Foundling Museum, London, UK/Bridgeman Art Library.

Fig. 26:
Thomas Gainsborough, *Portrait of John Gainsborough*, before November 1748. Oil on canvas, 61.2 x 51.1 cm. In the Collection of The Corcoran Gallery of Art, Edward C. and Mary Walker Collection.

Fig. 27:
Thomas Gainsborough, *The Fallen Tree*, c. 1750–53. Oil on canvas, 101.6 x 91.5 cm. The Minneapolis Institute of Arts. The John R. Van Derlip Fund.

Fig. 28:
Thomas Gainsborough, *Portrait of Mr and Mrs Andrews*, c. 1750. Oil on canvas, 69.8 x 119.4 cm. © National Gallery, London.

Fig. 29:
Arthur Devis, *Gentleman and Lady in a Landscape*, 1747–49. Oil on canvas, 70.2 x 90.6 cm. Wimpole Hall, The Bambridge Collection (The National Trust). Photograph: Photographic Survey, Courtauld Institute of Art.

Fig. 30:
Francis Hayman, *Portrait of Mr and Mrs George Rogers*, c. 1751. Oil on canvas, 90.3 x 69.8 cm. Yale Center for British Art, Paul Mellon Collection.

Fig. 31:
Thomas Gainsborough, *Portrait of a Man*, c. 1747. Oil on canvas, 58.4 49.6 cm. Memorial Art Gallery of the University of Rochester, Gift of Dr and Mrs Fred W. Geib.

Fig. 32:
Samuel (1696–1779) and Nathaniel Buck (d. 1774), *South-west Prospect of Ipswich*, 1741 (detail). Engraving, 24.5 x 77.5 cm. Ipswich Borough Council Museums and Galleries.

Fig. 33:
Thomas Gainsborough, *Mr and Mrs John Gravenor and their Daughters Elizabeth and Ann*, c. 1754. Oil on canvas, 90.2 x 90.2 cm. Yale Center for British Art, Paul Mellon Collection. Photo: Bridgeman Art Library.

Fig. 34:
Thomas Gainsborough, *Portrait of John Vere*, c. 1752. Oil on canvas, 76.2 x 63.5 cm. Private Collection on loan to Gainsborough's House, Sudbury, Suffolk.

Fig. 35:
Thomas Gainsborough, *Portrait of Mary, Mrs John Vere*, c. 1752. Oil on canvas, 76.2 x 63.5 cm. Private Collection on loan to Gainsborough's House, Sudbury, Suffolk.

Fig. 36:
Thomas Major after Thomas Gainsborough, *Landguard Fort*, 1754. Etching, 40.2 x 61.8 cm. Gainsborough's House, Sudbury, Suffolk.

Fig. 37:
Thomas Gainsborough, *Portrait of Admiral Edward Vernon*, c. 1753. Oil on canvas, 124 x 99.5 cm. Private collection, photograph courtesy of Richard Green Gallery, London.

Fig. 38:
Thomas Gainsborough, *Major John Dade (1726–1811) of Tannington, Suffolk*, c. 1754. Oil on canvas, 76.2 x 64.8 cm. Yale Center for British Art, Paul Mellon Collection, USA/Photo: Bridgeman Art Library.

Fig. 39:
Thomas Gainsborough, *Self-portrait*, 1754. Oil on canvas, 58.4 x 49.5 cm. Private collection/Bridgeman Art Library.

Fig. 40:
Thomas Gainsborough, *The Suffolk Plough*, c. 1754. Etching, 36.7 x 40.8 cm. Gainsborough's House, Sudbury, Suffolk, (Gift of Cavendish Morton).

Fig. 41:
Thomas Gainsborough, *Landscape with a Woodcutter courting a Milkmaid*, 1755. Oil on canvas, 106.7 x 128.2 cm. By kind permission of the Marquess of Tavistock and the Trustees of the Bedford Estates.

Fig. 42:
Thomas Gainsborough, *Landscape with Peasant and Horses*, 1755. By kind permission of the Marquess of Tavistock and the Trustees of the Bedford Estates.

Fig. 43:
Thomas Gainsborough, *Portrait of Hon. Charles Hamilton*, c. 1756. Oil on canvas, 74.9 x 62.2 cm. Richard L. Feigen & Co. New York.

Fig. 44:
Thomas Gainsborough, *The Painter's Daughters chasing a Butterfly*, c. 1756. Oil on canvas, 113.7 x 104.8 cm. © National Gallery, London.

Fig. 45:
Thomas Gainsborough, *Portrait of Sarah, Mrs Tobias Rustat*, c. 1757. Oil on canvas, 76.2 x 63.5 cm. Private collection, Australia.

Fig. 46:
Thomas Gainsborough,
Portrait of Revd Tobias Rustat, c. 1757.
Oil on canvas, 75 x 62 cm.
Gainsborough's House, Sudbury, Suffolk.

Fig. 47:
Thomas Gainsborough, *Portrait
of The Hon. Richard Savage Nassau*, c. 1757.
Oil on canvas, 124.5 x 98.4 cm.
The National Trust for Scotland,
Brodick Castle.

Fig. 48:
Thomas Gainsborough,
Portrait of John Sparrowe, c. 1758.
Oil on canvas, 127 x 101.6 cm.
Auckland Art Gallery Toi o Tamaki,
Mackelvie Trust Collection, purchased 1956.

Fig. 49:
Thomas Gainsborough, *Portrait of Henry
Wise*, 1758/9. Oil on canvas, 76.2 x 63.5 cm.
Private collection, United States.

Fig. 50:
Thomas Gainsborough, *Ox Cart
by the Banks of a Navigable River*, c. 1758.
Pencil and black chalk, 27.3 x 38 cm.
Private collection.

Fig. 51:
Thomas Gainsborough, *An Extensive River
Landscape with Cattle and a Drover and
Sailing Boats in the Distance*, c. 1757–59.
Oil on canvas, 75.2 x 111.5 cm.
Beaverbrook Art Gallery, Purchased with
a Minister of Communications Cultural
Property Grant and funds from the Estate
of Mrs Mae Atkinson Benoit, 1988.

Fig. 52:
Karel Dujardin, *Sheep and Goats*, 1673.
Oil on copper, 18 x 20 cm.
© National Gallery, London.

Fig. 53:
Thomas Gainsborough, *The Shepherd Boy*,
c. 1757–59. Oil on canvas, 82.5 x 64.8 cm.
Toledo Museum of Art, Gift of Arthur
J. Secor, 1933.21.

Fig. 54:
Thomas Gainsborough, *Margaret
Gainsborough gleaning* (fragment), c. 1758.
Oil on canvas, 76.2 x 63.5 cm.
Ashmolean Museum, Oxford.

Fig. 55:
Thomas Gainsborough,
Portrait of a Young Woman, c. 1759.
Oil on canvas, 76.2 x 63.5 cm.
Museo de Arte Foundation, Inc. Luis A. Ferré
Foundation, Inc. Ponce, Puerto Rico.

Fig. 56:
Thomas Gainsborough, *Portrait
of William Wollaston*, c. 1759.
Oil on canvas, 126 x 97.8 cm.
Ipswich Borough Council Museums
and Galleries.

Fig. 57:
Thomas Gainsborough, *Portrait
of Robert Nugent, Lord Clare*, 1759.
Oil on canvas, 127 x 101.6 cm.
City of Bristol Corporation, UK.

Fig. 58:
Thomas Gainsborough, *Portrait
of Uvedale Tomkins Price*, c. 1760.
Oil on canvas, 124.4 x 99.1 cm.
Neue Pinakothek, Munich.
Photo: Bayer & Mitko, Artothek.

Fig. 59:
John Wood the Elder (1704–54) (attr.),
*Elevation and ground plan of Kingston House,
Abbey Street*, c. 1745. Pencil, ink and ink wash,
two sheets, 22.8 x 34.6 cm and 22.9 x 34.5 cm.
British Architectural Library, RIBA, London.

Fig. 60:
Thomas Gainsborough, *Self-portrait*, c. 1759.
Oil on canvas, 76.2 x 63.5 cm.
By courtesy of the National Portrait Gallery,
London.

Fig. 61:
Thomas Gainsborough, *Portrait
of Mrs Margaret Gainsborough*, c. 1759.
Oil on canvas, 76 x 63.5 cm.
Staatliche Museen zu Berlin,
Bildarchiv Preussischer Kulturbesitz,
Gemäldegalerie/cat. no. 2200.
Photo: Jörg P. Anders.

Fig. 62:
Thomas Gainsborough,
Portrait of Ann Ford, 1760.
Oil on canvas, 196.9 x 134.6 cm.
Cincinnati Art Museum,
Bequest of Mary M. Emery.

Fig. 63:
William Hogarth,
The Lady's Last Stake, 1759.
Oil on canvas, 91.4 x 105.4 cm.
Albright-Knox Art Gallery,
Buffalo, New York, Gift of
Seymour H. Knox, Jr., 1945.

Fig. 64:
Thomas Gainsborough,
George Pitt, First Lord Rivers, 1769.
Oil on canvas, 234.3 x 154.3 cm.
© The Cleveland Museum of Art, 2002.
Gift of the John Huntington Art
and Polytechnic Trust, 1971.2.

Fig. 65:
Thomas Gainsborough, *Isabella, Viscountess
Molyneux (later Countess of Sefton)*, 1769.
Oil on canvas, 233.7 x 152.4 cm.
The Board of Trustees of the National
Museums and Galleries on Merseyside
(Walker Art Gallery, Liverpool).